IMAGES
of America

THE
KEY PENINSULA

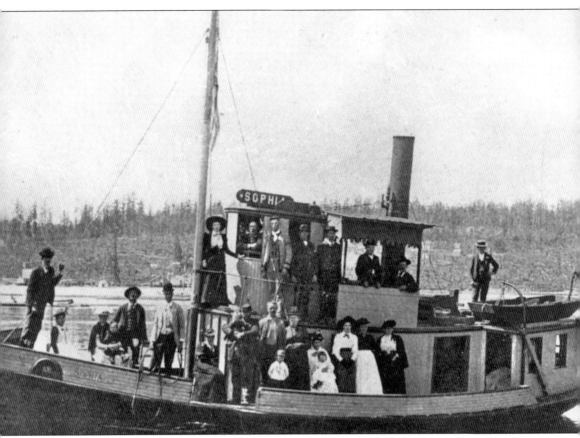

Like "a swarm of mosquitoes," as many as 2,500 small vessels plied the waters from Olympia to Alaska from the 1850s to the early 1940s. In Lakebay, Carl Lorenz and his sons crafted *Sophia*, the first steamship built on the Key Peninsula. Named for Lorenz's mother, *Sophia* became one in a line of "Mosquito Fleet" boats that connected the Key Peninsula to the world beyond. The day of her launching brought out residents from the whole peninsula. Aboard this 1886 trip was Lorenz's daughter Meta.

ON THE COVER: This Longbranch School, built in 1885 at the head of Filucy Bay on land donated by Joe Shettlerow, was No. 32 in Pierce County. It served the children of the lower peninsula through eighth grade until it combined with No. 87, and a new two-room school, No. 328, was built a few miles north, near the current Longbranch Improvement Club. This photograph was taken about 1898.

IMAGES
of America

THE
KEY PENINSULA

Colleen A. Slater

ARCADIA
PUBLISHING

Published by Arcadia Publishing
Charleston SC, Chicago IL, Portsmouth NH, San Francisco CA

Printed in the United States of America

Library of Congress Catalog Card Number: 2007921324

For all general information contact Arcadia Publishing at:
Telephone 843-853-2070
Fax 843-853-0044
E-mail sales@arcadiapublishing.com
For customer service and orders:
Toll-Free 1-888-313-2665

Visit us on the Internet at www.arcadiapublishing.com

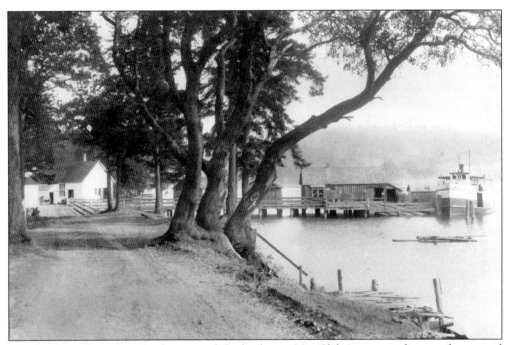

The first bayside road at Vaughn crossed the bridge on Van Slyke's cove, with a warehouse and stores on the other side. The steamship *Burro* waits at the dock to carry mail, freight, and passengers in 1920. The current boat ramp lies at the far side of this bridge. (Courtesy Dulcie Schillinger.)

CONTENTS

ACKNOWLEDGMENTS

A work like this cannot be done without help from many others. The Key Peninsula Historical Society (KPHS) provided access to their collection of photographs and documents. Unless otherwise noted, images were provided by KPHS.

To Julie Albright, my helpful editor at Arcadia Publishing, I appreciate your guidance and quick responses.

To those who have gone before, researching, writing, and taking photographs, I owe a debt of gratitude.

Thank you to the many who offered their own collections of photographs, tapes, books, written histories, and clarified facts: Arlene Babbitt, Judy Bradshaw, Julia Bergstrom, Marguerite Bussard, Catherine Skahan Carlson, Joanne Clark, Ann Lorenz Craven, Stuart Curry, Chester E. Dadisman, Russell Dahl, Peggy Davidson Dervaes, Ed Edwards, Evelyn Dadisman Evans, Elvin Floberg, Helen Stolz Fravel, Jean Humphreys, Nona Jorgensen, Edyth Johnson family, Hazel Kingsbury, Mary Georgene Knudson, Mindi LaRose, Don Lind, Marianne McColley, Pearlita McColley, Hugh McMillan, Don Mills, Joyce Niemann, Debbie Nichols, Laura Knapp Otto, Marge Radonich, Sylvia Retherford, William Roes, Dulcie Schillinger, Evelyn Shyvers, Adelle Smith, Gene Stone, David Stratford, Rodika Tollefson, Margaret Tornquist, Bud Ulsh, Harmon and Jane Van Slyke, Jessie White, and Helen Wolniewicz.

Shirley Schiller provided great census research help.

To my readers and editors, especially Jan Walker, Suzanne Hilton, and the members of the Gig Harbor Writers' Circle who listened to some rough drafts, I appreciate your time and support: Kathryn Arnold, Garner Conn, Linda Glein, Erne Lewis, Kathleen O'Brien, Roy Parfitt, and Mary Magee, who introduced me to Arcadia Publishing.

Thanks to all who encouraged my writing, including family, friends, and high school English teacher "Mrs. B," Dorothy Lusby.

Special thanks to my patient and supportive husband, Frank, who allowed me to let some things go, who ran errands and researched, and who was first and last reader. You are special.

INTRODUCTION

Tall evergreens—fir, cedar, and hemlock—and deciduous trees—maple, alder, and madrona—covered the land when it was called the Indian Peninsula. In some areas, trees again sweep down to saltwater shores, although most old-growth forests were logged off in the early 1900s.

Peter Puget, lieutenant for Capt. George Vancouver, brought a small party to explore Puget Sound in 1792. They encountered natives along the eastern peninsula shores and traded with one group.

The first two white settlers arrived at opposite ends of the peninsula about the same time. Pierre Legard built a cabin on a southeastern bay; William Vaughn staked a claim on a northwestern one.

The struggles needed to wrest a home and livelihood from the forests proved too much for some; others, more than up for the challenge, dug in, planted roots, and encouraged friends and relatives to join them in this new paradise.

By 1900, more seekers of freedom and farms expanded the peninsula population. Many boats traveled the waters of Puget Sound, the roadways of the time. A dock or float provided each community with access to boats that carried passengers, supplies, and mail.

The James Woodburn Crawford Ulsh family, one of the first at Lakebay, constructed a sailboat to cross the sound. Ulsh built much of the Penrose family's summer retreat, the Madronas. George Allen, B. F. Odell, and Oliver Verity built a large rowboat to explore the peninsula. The Howard Rodman family arrived in their yacht, *Pedro*.

Farmers shipped produce, chickens, and eggs by way of the Mosquito Fleet steamers. Shipments sent off the peninsula included lumber, wild huckleberries, grapes, clams, oysters, holly, and evergreen brush.

Carl Lorenz allowed neighbors to ride his lumber boat and realized a need for scheduled trips for passengers as well as for freight. The Lorenz "company eagle," a cast-iron bird that graced the original Lorenz mill saw arbor, spread its wings above the *Sophia* pilothouse in 1894. Transferred to the *Meta* in 1888, the eagle was "promoted" with each new boat acquired. The last boat to carry the eagle was the *Virginia V*. The Lorenz eagle was removed from the *Virginia V* and presented to the Puget Sound Maritime Historical Society in 1954.

Gilbert Lorenz, grandson of Carl, told of a fireman on the *Tyrus* who, after a night with the bottle, complained that the eagle watched his every move.

By 1925, improved roads, railroads, and car ferries competed with the steamboats. Residents wanted faster transportation to towns on the mainland. When *Arcadia* made the last run with the mail for Lakebay in 1941, the end of an era arrived. Although *Arcadia* was later used with others as excursion boats, the days of the Mosquito Fleet passed into history.

Except for Longbranch, communities constructed halls before churches. The first community building served multiple purposes. Most contained a few books and were called library halls to keep them off the tax rolls.

School, church services, meetings, plays, recitals, and later, movies, took place in these early buildings. Culture bloomed in various ways, with offerings of lectures, art classes, and musical entertainment, especially in Home.

George Henry Bassett and Jacob Maxwell, both journalists and horticulturists, organized a horticultural society in Vaughn, open only to men. Maxwell offered land to build a hall. The women reacted by forming the library association, with men prohibited. According to their records, they met monthly for the raising of money during the full moon for safer passage on rough trails. They set up a floor-to-ceiling padlocked case of shelves in the post office, re-covered donated books, and opened the library on Saturday afternoons.

Home, where education held priority, produced the youngest student to graduate from the University of Washington at that time. Ernie Falkhoff began university studies at age 13, graduated with honors, and became a lawyer.

Joe Smith, a war correspondent and political columnist, retired on the peninsula to grow bulbs and other flowers in 1917. He printed the *Joemma Bulletin* to advertise his wares, as well as to give gardening hints and other commentary.

Joe Parker put out a small paper called the *Peninsula Citizen* from his print shop in Vaughn in the 1930s. *Key Peninsula Breezes*, printed by Key Peninsula businessmen, appeared in 1931, with Vaughn church pastor Paul Gates as editor.

The *Key Peninsula News*, a current nonprofit monthly publication with a circulation of 8,500, began as a newsletter of the Key Peninsula Civic Center.

Few doctors serviced the area in early days. Cornelia Hall would not allow her husband, Dr. John Hall, to deliver babies in Vaughn. "Grandma" Amanda Wright carried out that service, as did others in various communities. Friends often acted as midwives for each other.

Jeanne Broadsack, public health nurse practitioner, brought supplies from Tacoma for a clinic in a building on the Longbranch Church grounds in 1972. Her first patient was a cat. Judy Wilson and Nat Knox, retired navy nurses, helped at the clinic.

In 1981, Dr. William Roes put in a half day each week at the clinic to become full time in 1984. Key Medical Center now provides up-to-date health care.

A wooden drawbridge built on wooden pilings in 1892 was first in a series of bridges to connect the Key and Gig Harbor Peninsulas at Wauna sandspit. A large key fit into a slot-swinging turnstile, and the bridge center pivoted to allow tugs in to pick up Wilson Logging Company log rafts. When tugs neared Dead Man's Island, they blew whistle signals, and members of the Knapp family in Purdy opened the bridge.

A second bridge, a high arched wooden one constructed in 1905, collapsed when strong tidal currents swept away some pilings. A bigger, better bridge with the swing span of steel was moved from Puyallup to replace the previous one in 1919.

Peninsula residents with automobiles wanted better roads and bridges. A trip from the upper end of the peninsula to Tacoma by way of Shelton and Olympia took two hours or more by car. Tacoma organizations promoted the idea of a bridge across the Tacoma Narrows in the 1920s. Mitchell Skansie of Gig Harbor held a 10-year ferry service contract that included immunity from competition. Any bridge project meant buying off his contract—an expensive arrangement.

The U.S. Navy and U.S. Army supported the idea of a Narrows bridge because it made a closer link between the Bremerton Navy Yard and McChord Field and Fort Lewis. In the event of war, such a bridge would become a necessity.

Occupations changed over the years. After Pearl Harbor was bombed on December 7, 1941, many steamer captains stopped their runs and started work at the Bremerton Navy Yard. Although loggers and farmers still work on the peninsula, newer businesses offer services and employment.

Commercial oyster growing began in Vaughn Bay in 1899 and in other bays around the peninsula in the early 1900s. Most of those tidelands are now private property. Minterbrook Oyster Company, started in 1934 by Hubert and Mary Secor, ships these shellfish worldwide.

Chester and Dorothy Van Slyke opened their Photo Arts photography studio in Vaughn in 1949. They took several of the photographs used in this book.

William W. Seymour of Tacoma invited some boys to camp on his Glen Cove property in the summer of 1903. Seymour loaned the property to the YMCA as an outing center two years later. By 1908, more than 60 boys camped in 10 tents, with a cookhouse and dining pavilion. Campers rowed across the cove to obtain water from the Petersen family. Seymour deeded the land to the YMCA in 1920. Members of the "Dippy Club" ran, sans clothing, to dive into the cove in 1923. Some campers maintained the tradition but later required swimwear.

The Key Peninsula boasts two waterfront state parks with picnic and camping facilities —Penrose and Joemma Beach—plus Rocky Creek Conservation Area and Haley Property, which is acreage with water access. An annual Volksmarch occurs at Penrose, and various parks offer hiking trails.

The Wauna sandspit continues to be a popular place for swimmers, boaters, beachcombers, and picnickers.

Key Peninsula Sports Park and Fairgrounds maintains facilities for baseball, soccer, tennis, horseshoes, picnicking, and camping. The annual Key Peninsula Fair sets up at the park, and assorted sports tournaments are held there each year.

Dorothy Wilhelm, host/producer of *My Home Town* documentaries for Comcast TV, filmed a program on the "community" of Key Peninsula. It aired in September 2003 and is still included in the broadcast schedule.

No city exists on the peninsula, but rather a collection of communities of varying size, each with particular historic sites, events, and traditions.

The stories in this book tell but a small portion of the lives of the people who lived and continue to live in this evergreen countryside. Second, third, and fourth generations of early settlers enjoy sharing their memories and oral traditions with newcomers or other old-timers.

A single volume cannot encompass the rich history of the past 150 years, but this sample shows the kind of people who came to this area, liked what they found, and worked to make the Key Peninsula what it is today.

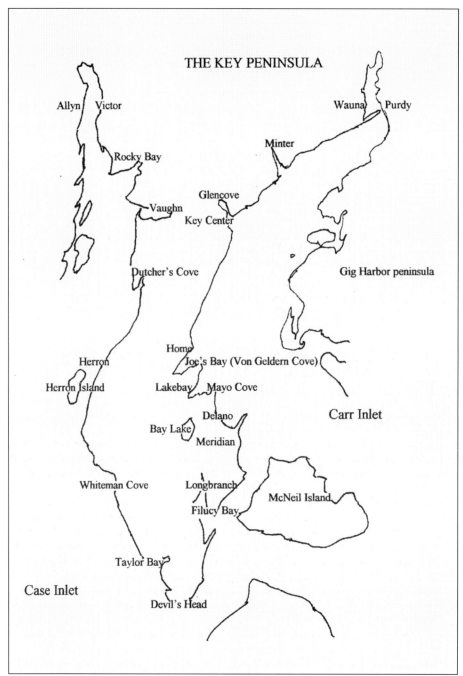

THE KEY PENINSULA

Allyn Victor Wauna Purdy

 Minter

Rocky Bay

 Glencove

 Vaughn

 Key Center

Dutcher's Cove Gig Harbor peninsula

 Home

 Herron Joe's Bay (Von Geldern Cove)

Herron Island Lakebay Mayo Cove

 Delano Carr Inlet

 Bay Lake

 Meridian

 Whiteman Cove Longbranch

 Filucy Bay McNeil Island

Case Inlet

 Taylor Bay

 Devil's Head

The Key Peninsula, about 16 miles north to south and between 2 and 5 miles wide, connects to the Kitsap Peninsula on the north, and lies between Case and Carr Inlets in Puget Sound. A U.S. government survey team exploration headed by Charles Wilkes mapped much of the Puget Sound coastline in 1841. They named Case and Carr Inlets for Lt. Augustus Ludlow Case and Lt. Overton Carr; Hartstene Island for Lt. Henry J. Hartstene; McNeil Island for William Henry McNeil, captain of Hudson's Bay *Beaver*; Herron Island for barrel maker Lewis Herron; and Von Geldern Cove for another member of the party. (Courtesy author's collection.)

One

PEOPLE OF THE
WATERS AND THE
GRASS COUNTRY

The Native Americans who lived in the general vicinity of the Indian Peninsula came from the Nisqually, Squaxin, and Twana tribes. These peoples would go to battle to defend themselves or to obtain new slaves but were not aggressive. At times, fleeing their villages or using their wits was their best defense.

A Twana story tells of the tribe camping on the Skokomish during salmon season, upriver from Hoods Canal. The men entered the forest to cut poles for the fish weir. Snohomish warriors rushed the camp, bound the women and children, gathered plunder, and placed captives and goods in their canoes. A single boy escaped to warn the men, who felt helpless without their spears. They dashed to the mouth of the river. A strong north wind stirred up the waters. The Twana men scouted until they found the Snohomish asleep at the foot of a bluff. They gathered a pile of boulders at the edge of the steep bluff. They made some clubs. A few men crept down to the beach, and then the others hurled the mass of boulders over the edge. The Twanas on the ground quickly finished off any Snohomish survivors.

These tribes all spoke some form of the Salish language. Twanas and Squaxin spoke Lushootseed, a subdialect of Salish. The Squaxin called themselves People of the Water. The Twanas, the Big River People, are now known as Skokomish. The Nisqually are People of the Grass Country. These first people on the peninsula lived in harmony with the land and most of their neighbors. They befriended the white strangers who arrived in boats, wagons, or on horseback in the mid-to-late 1800s. The arrival of the white men on the Key Peninsula did not change the habits of the natives for several years; they continued to camp in their traditional areas and to hunt, fish, dig clams, and gather berries and plants well into the early 1900s.

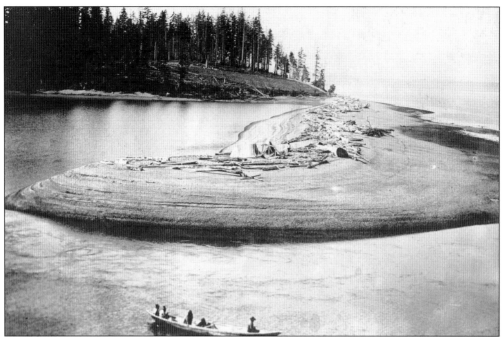

Native Americans seen here in a dugout pass through the Vaughn Bay channel in the early 1900s, their campsite on the sandspit. They smoked fish or set it on frames to dry in the sun and wind. Deer, bear, fox, coyote, and other small mammals varied the standard diet of seafood. Cured hides made tents and clothing. Bones became tools. Women picked huckleberries, blackberries, madrona, salal, kinnikinnick, and other berries to eat fresh or dry, or pounded and baked them into cakes for later use. Dried roots included skunk cabbage, cattail, and lily. They dried seaweed for salt flavoring and to trade with inland tribes.

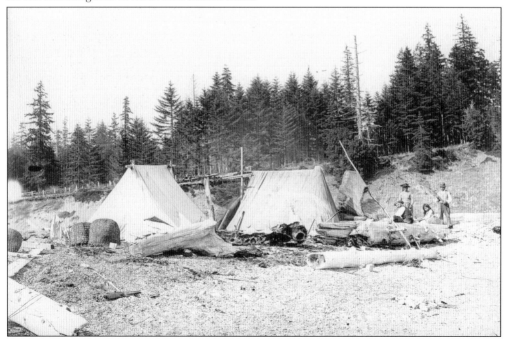

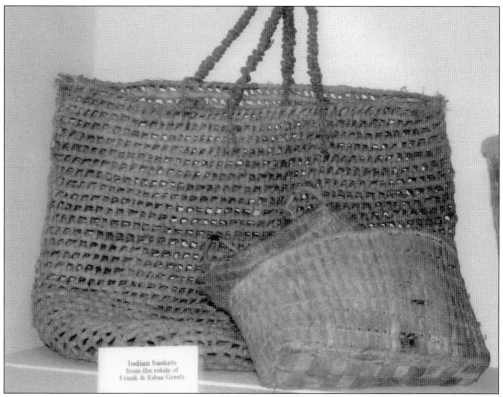

Indian baskets
from the estate of
Frank & Edna Greely

Native American baskets from the Frank and Edna Greeley collection are displayed in the KPHS museum. The basket on the right in the lower picture was given to Bess Yeazell Woodruff in trade with a Native American on the Filucy Bay sandspit in the 1890s. These people used western red cedar for lodging and dugout canoes. The women expressed their artistry by weaving cedar bark into baskets and clothing.

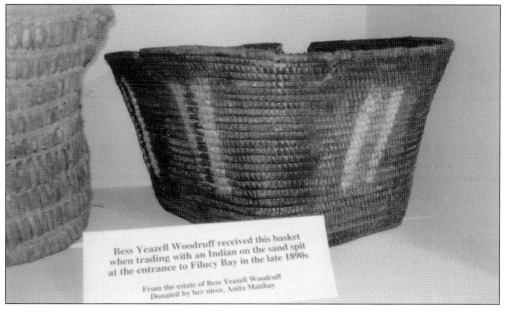

Bess Yeazell Woodruff received this basket when trading with an Indian on the sand spit at the entrance to Filucy Bay in the late 1890s

From the estate of Bess Yeazell Woodruff
Donated by her niece, Anita Matthay

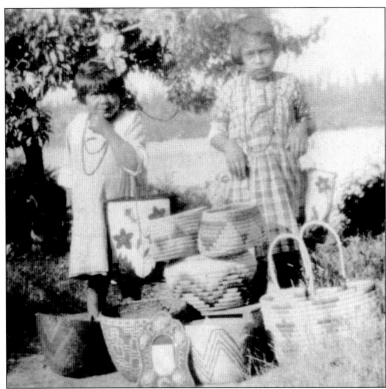

Teresa Nason, on the left, taught basket making to Squaxin women in the 1930s. The other girl is unidentified. Tribal women gathered wild grasses for mats and baskets, which added strength and color to these much-used objects. (Courtesy Squaxin Tribal Museum.)

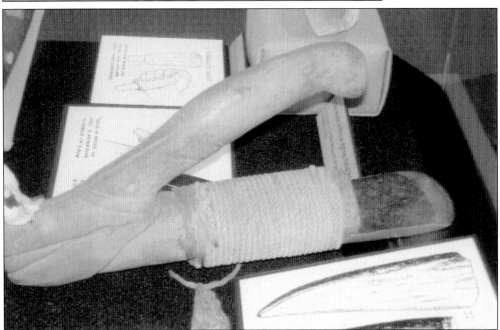

A steel adze for carving cedar dugout canoes replaced earlier ones of bone or stone. Men felled tall, straight cedars, cut them in half lengthwise, and then hollowed out the centers by scraping, cutting, and burning. Fathers passed on the art of canoe making to sons. The best canoe makers were in high demand, as not all men constructed their own canoes. (Courtesy Squaxin Tribal Museum.)

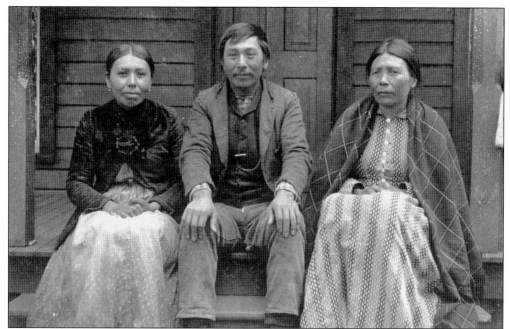

Native American friends of Vaughn storekeeper Harry Coblentz posed for a photograph by Coblentz in the 1890s. These people were probably from the Squaxin tribe. When natives made purchases in those days, they were unable to add amounts, so they bought one item, counted their money, bought another, and continued until they acquired what they wanted or ran out of money.

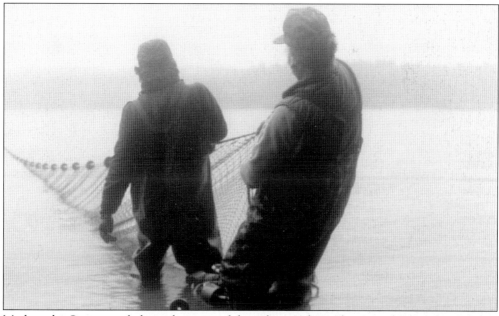

Modern-day Squaxin tribal members seine fish in their traditional waters of Case Inlet. Salmon, plentiful in the waters of Puget Sound, provided their main food and were used in their special ceremonies. Natives constructed fishing lines and nets of nettle or milkweed fibers. Besides fishing, they picked up, dug, or trapped in baskets a variety of sea life, including clams, crabs, mussels, oysters, and shrimp. (Courtesy Squaxin Tribal Museum.)

Elmer Skahan's great-grandfather Varner crossed the plains in a covered wagon and married a Native American. The local whites did not want a mixed-marriage couple near their community, so Varner built a cabin near the Minter sandspit, where three sons were born. Skahan lives not far from where his grandfather was born. More Native American than white, his local roots are among the earliest on the peninsula.

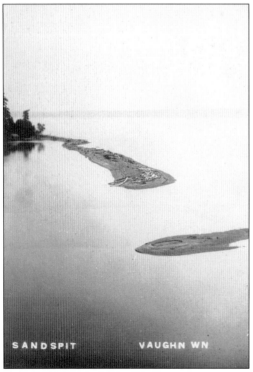

SANDSPIT VAUGHN WN

Old-timers say trees grew on the Vaughn sandspit at one time, but too many bonfires burned the protective driftwood. Local residents set in pilings and timbers to maintain it, but it once again divides during high tides, as seen in this early 1900s photograph. One local family hosts an annual kite-fly on the sandspit, a once favorite place for clambakes and picnics.

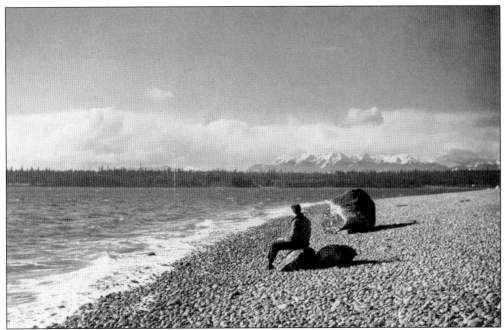

Fewer and smaller trees fill the landscape since the Native Americans fished these waters and camped on this land, but the grandeur of the Olympics has changed little. The above picture was taken from Sunshine Beach, just west of Vaughn Bay, about 1950. Below, an aerial view of Filucy Bay, with modern roads and buildings around Longbranch, shows Anderson Island across Carr Inlet, with the mainland in the background. (Courtesy Dulcie Schillinger and KPHS.)

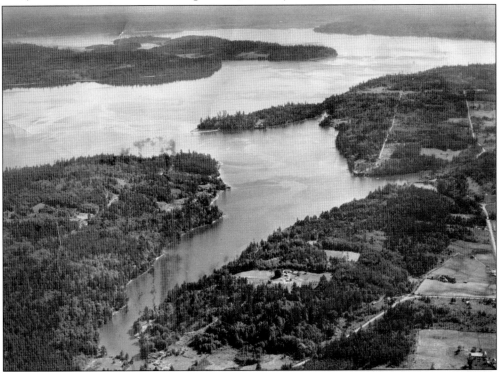

Alfred Van Slyke moved his family from Kansas to Tacoma in 1885. Hugh Farley, a friend from Kansas who lived in Vaughn, told Van Slyke the growing community needed some commercial establishments—a hardware store in particular. Van Slyke checked it out, attending a community meeting. He returned in August 1887 with Kansas friend George Prater to select property and a site for a store. By then, the Critchfield family, the first permanent settlers in Vaughn, moved to Puyallup, and Van Slyke filed on their patent. He used a two-room building constructed by Critchfield for a store and post office. His family moved from Tacoma into Critchfield's small home near a creek that flowed into a small cove, where Van Slyke built his sawmill. He became Vaughn's second postmaster—after Alice Hunt, who collected the mail in her shopping basket on trips to Tacoma. Van Slyke served for 10 years and then another 10 later. His son, Bird Finch, the first child born in Vaughn, entered the world in the back room of the post office. (Courtesy Dulcie Schillinger.)

Two

COMING OF
THE WHITE MAN

Pierre Legard tended to avoid other whites, preferring Native American acquaintances. They provided him with information and friendship.

Charles Taylor, the first permanent settler on the peninsula, went to sea to escape a life of poverty. He jumped ship on the northwest coast because of cruelty from his superiors. Fearful of being caught and beaten or killed, he avoided white settlements but befriended natives who guided him through forests and across the waters.

Taylor traveled to a sheltered bay between timbered bluffs northwest of Devil's Head. The natives supplied him with a canoe and food and kept in touch with him. Taylor built a cabin and furniture from driftwood. He cleared land and planted a garden and orchard, although his Native American friends insisted he could survive well on what the sea and forest provided.

The first shipment of lumber to San Francisco from the peninsula included some of William Vaughn's. He served in the 2nd Regiment of the Washington Volunteers during the Indian Wars of 1855–1856. After the war, armed squatters occupied his land in Vaughn. He abandoned it and settled in Steilacoom.

Joseph Shettlerow started a small logging operation on Filucy Bay in 1859, with Legard as partner. The Native Americans accepted Shettlerow in the area because of their relationship with Legard. Shettlerow built a large home north of the bay. Later settlers used his earlier cabin as their first home. He donated land for the first school at Longbranch in the early 1880s. Joe Faulkner built a cabin at the head of Von Geldern Cove in 1870. Many locals call the cove Joe's Bay to honor its first settler.

William and Sarah Creviston arrived at Taylor Bay in 1871. Their son Bill Victor held the honor of being the first white child born on the peninsula.

Harry C. Winchester logged on the northeast side of Balch's Cove by the early 1870s. Problems with his early logging ventures turned him to water transportation. He continued to purchase forested land. A partnership with Hans Nicholas Petersen in 1882 returned him to logging. Petersen began his logging education as a skid greaser.

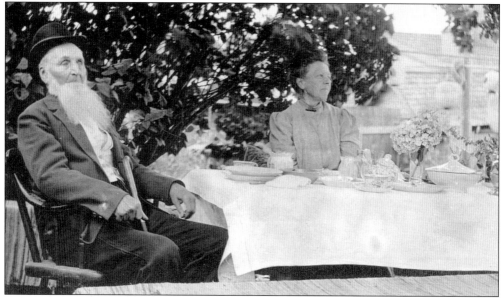

William Vaughn sent this picture postcard of himself and his wife, Caroline, at their Steilacoom home in 1911. He wrote that he had planted the trees 50 years previously. In 1913, they enjoyed a picnic with friends and a host family on Vaughn's original homesite on the bay named for him. (Courtesy author's collection.)

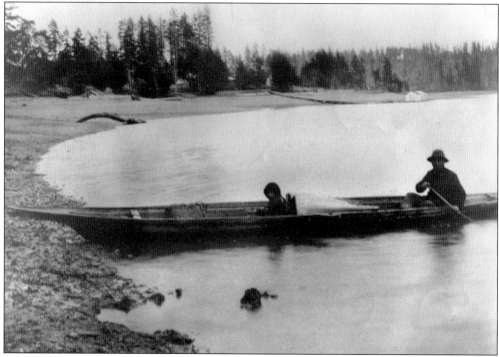

Fred Prater, with his sister Belle, paddles a Native American dugout canoe in Vaughn Bay about 1898. Belle was born in Vaughn in 1892. The George Prater family, friends of the Alfred Van Slykes from Yates Center, Kansas, settled on Rocky Bay. When Van Slyke asked Prater to go with him from Tacoma to check out Vaughn, Prater's boss said, "It's all gravel and huckleberry brush."

Mary Jeanette Van Slyke was tending the Vaughn store on a day when Native Americans paddled from the sandspit. They bought large quantities of canned tomatoes and vanilla extract. When her husband came home, she asked why they wanted so much extract, as she was sure they did no baking. He told her she could be arrested for selling alcohol to them. (Courtesy Dulcie Schillinger.)

Harry Staley Coblentz, friend of Alfred Van Slyke, partnered with him in the mill and store operations. Together they built a dock and a floating walkway from the store. Coblentz continued with the store, while Van Slyke ran the mill. Coblentz later moved to Tacoma, where he managed a store.

Coblentz photographed his son Walter, named for Walter Eckert of Eckert Island. Eckert and his brother rowed to Vaughn to school from their island home in all kinds of weather. For a time, he stayed with the Coblentz family. Later he directed the Vaughn church choir for about 20 years.

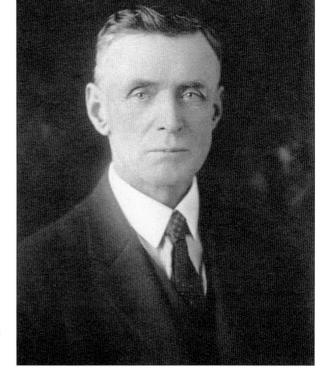

Capt. Ed Lorenz sits for his portrait. Lorenz and brothers Otto and Oscar qualified as steamboat men on the *Sophia*. Only Ed remained a pilot. He later captained *Arcadia*, the longest-lived boat of the Lorenz-Berntson fleet. His granddaughter Ann lives on the peninsula. (Courtesy Ann Lorenz Craven.)

Rawleigh Smythe poses with his dog below the former George Minter home. His parents, Fred and Cora Smythe, managed the post office until it closed in 1936. A historic marker highlighting the house sits across the road. The Smythes' dream of a fish-research facility became reality with the construction of the state salmon hatchery near their house in 1986.

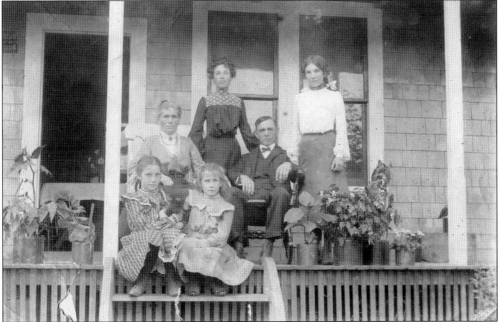

The George Allen family sits on their porch about 1905. A fire burned this home two years later. Grace, left, and Leila stand behind their parents, Sylvia and George, while Georgia and Glennis sit on a step. The Allens named Glennis for where she was born, a communal-living settlement south of Tacoma. (Courtesy Sylvia Retherford.)

Early homes on the peninsula varied in size and structure. Andrew Olson, a Swedish immigrant, arrived on the peninsula in 1886. Five children were born in the cabin seen here in 1923. Great-great-granddaughter Nicole Niemann Carr and her husband built their new home nearby. She displays a sign indicating that her home lies on the spot where great-grandfather Elmer Olson built "Chicken House No. 5."

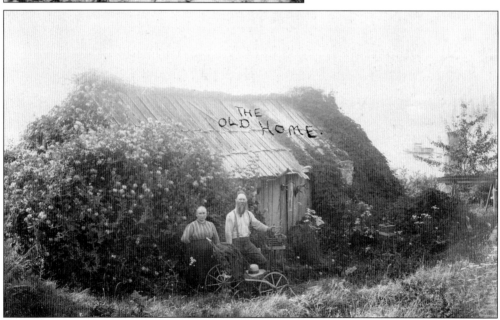

The first home of Dr. John Alexander Hall in Vaughn was "nothing more than a shack," says great-granddaughter Dulcie Schillinger. They built a larger home on this hill overlooking the bay. The Hall daughters married Van Slyke brothers. John Fletcher Hall married Minnie Carney, also from Yates Center, Kansas, and her parents gave their name to Carney Lake. (Courtesy Dulcie Schillinger.)

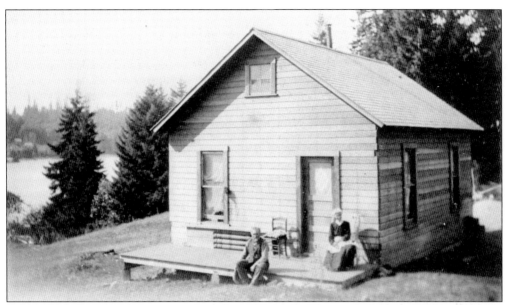

Some people built simple homes, such as this 1912 one by Thomas and Hannah Bill of Vaughn. Many years after this house sold, new owners lifted kitchen shelf paper, found the Bills' marriage certificate beneath it, and returned the document to a member of the family. Bill donated land for the First Christian Church in Vaughn, which later combined with the Congregational church to become Vaughn Community Church of Christ. (Courtesy author's collection.)

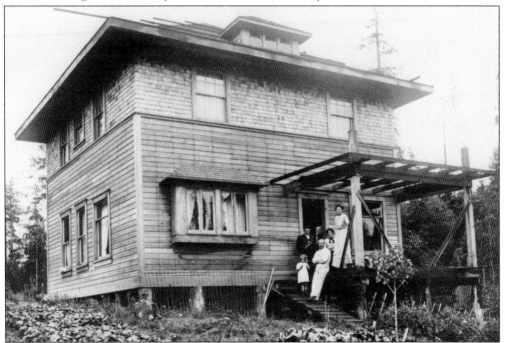

In 1913, Gaston and Leah Lance, in white, pose at their house in Home with Jeanette Clerc, her daughter Madeleine, and an unidentified man. By this time, many people built larger and more comfortable homes than the earlier minimal dwellings. Residents enjoyed more time for visiting and other social activities.

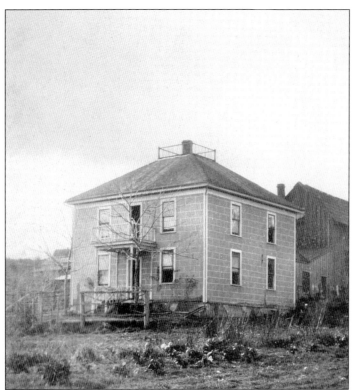

Martin Van Buren Dadisman built this house of concrete patterned on his previous Virginia home, which he also built. His children carried gravel from the beach to make the concrete. Sand in the concrete eventually caused deterioration, and the house was razed many years ago. (Courtesy Chester E. Dadisman.)

Anton and Akka Van Tuyl traveled from Holland with a large wooden chest. Upon arrival in Home, Akka painted the lid and stood the trunk on end for a cupboard. The Van Tuyls both gave music lessons to many children and adults on the peninsula. Anton taught music at Vaughn Union High School. They lived in the second schoolhouse of Home.

Moritz Lehman, a bookbinder in New York, raised chickens in Home. His daughter Charlotte "Lottie" married David Dadisman. Granddaughter Evelyn Dadisman Evans and her husband, William, tore down the Lehman house to build their home on the site. This etched stag from the Lehman front door now graces a window in the Evans home. She recalls running up the hill to stay with Grandma Lehman and sleep in her large feather bed. The Evans home sits on a hill above Joe's Bay, with a view of Mount Rainier on clear days. Regina Lehman, a lace maker, brought her lace-making tools to Home. Evans, below, has given presentations on the lace made by her grandmother. (Courtesy Evelyn Dadisman Evans.)

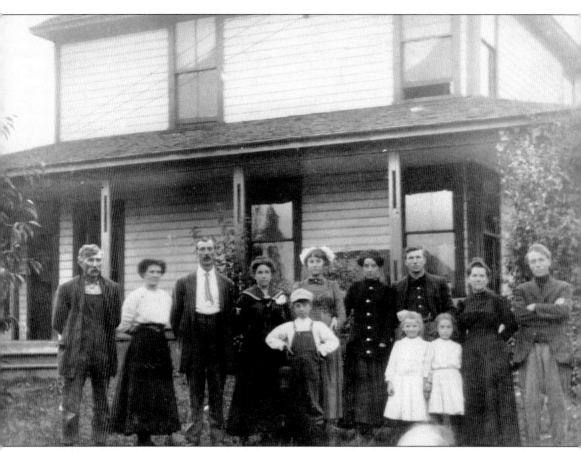

William J. King's home, just north of the current post office in Home, held the first telephone exchange on the peninsula. The Sound Telephone Company incorporated through the sale of stock about 1911, and the first lines went up soon after. The company's franchise ran from the southern tip of the peninsula to 118th Street in Elgin by 1920; long-distance charges began beyond that point. The company moved with each new owner—from the Kings to the Evanses, to the Ladens, to the Gateleys, to Denver Yates, who moved it back to Home. King, at left, worked to get the farmer's co-op to locate in Lakebay. Called "The Huckleberry King," he, at one time, bought more huckleberries than anyone else on the peninsula. He also developed an early berry cleaner.

Three

No Place Like Home, or Vaughn, or Lakebay

Each community on the peninsula, unique in origin, began life influenced by its first settlers. Three men, Allen, Odell, and Verity, founded Home. They believed people should be allowed to do as they pleased, as long as their actions did not impinge on the rights of their neighbors. Tolerance and hospitality were community hallmarks. Home advertised that its community had no church, no saloon, and no policemen. The community's creed included freedom of and from religion.

William Creviston looked for an inland site to farm when his wife became terrified of the water at Taylor Bay after a near drowning of one of her children. He walked through the forest to find new property and came across a body of freshwater he named Bay Lake. He called Mayo Cove, on the saltwater, Lake Bay, and the name stuck for the later community on its shores.

John W. Critchfield preempted 80 acres of land in Vaughn in 1882 and became the first permanent settler there. He purchased sawn lumber in Olympia and had it delivered by tug and scow to build a two-story home.

George and Lucinda Minter arrived in 1882. She became the Minter postmaster in 1885. They operated a hotel for visitors or travelers, with room rates from $1.50 to $2. William Kernoodle, teacher and postmaster, renamed the community Elgin in 1892. The current school is Minter.

Springfield, named and platted by George McCormick and James and Deborah Wickersham, became Wauna, a Native American word meaning mighty waters, when Mary Frances White was postmaster. White and her husband, William, built a store and a large home called the Wauna Lodge, where they housed overnight visitors. The store and postmaster position stayed in the family for three generations.

By 1982, the building housed only the Wauna post office. A new post office at Lake Kathryn, a few miles up the hill, was built in 1990. The old store/post office was on the National Historic Site register. Following controversy between those who wanted it maintained as a historic site and others who viewed it only as an eyesore, it was removed from the register and demolished in 2006.

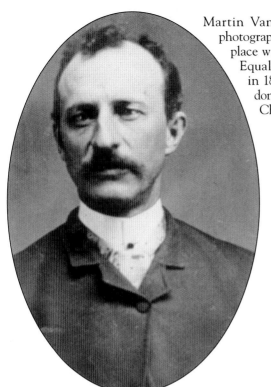

Martin Van Buren Dadisman, shown in this 1893 photograph, left his home in Luray, Virginia, to find a place without prejudice to raise his family. He tried Equality in Skagit Valley but settled on Home in 1899. He purchased 70–80 acres of land and donated much of it to the Home colony. (Courtesy Chester E. Dadisman.)

Lois Waisbrooker, who espoused women's sexual rights and nude bathing, wrote articles that helped fuel the fire that resulted in the government closure of the Home Post Office in 1902. Critics considered *Clothed by the Sun*, which Waisbrooker authored with Mattie Penhallow, obscene. Ken and Sylvia Retherford built their home on this site. (Courtesy Sylvia Retherford.)

Children of Home, about 1911 or 1912, pose for this picture. From left to right are (first row) unidentified, Clara "Tootsie" Rubenstein, Lulu Ault, Opal Govan, Rose Ostroff, and Pearl Schultz; (second row) Ann ?, Lynda Minor, Pearl Baracher, Max Shane, Dora Shane, Minnie Heiman, and ? Zeidman; (standing) Victor Heiman and Alec Cohen. (Courtesy Chester E. Dadisman.)

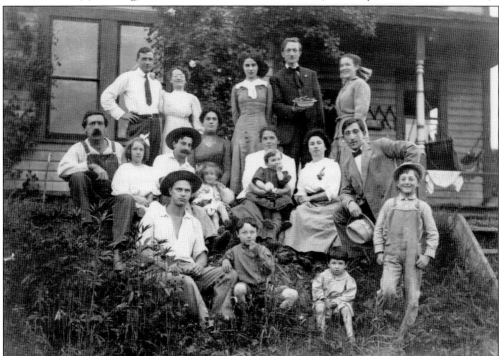

Some Home residents gather in 1912, including Joe Kopelle and Frans Erkelens, the young men in identical wide-brimmed hats; Erkelens is the lower one. Glennis Allen stands at upper right.

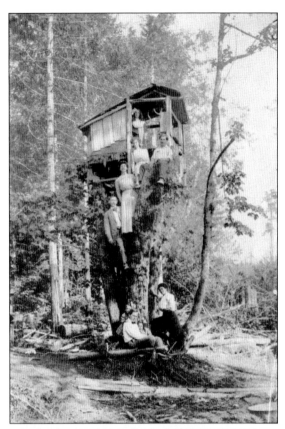

Joe Kopelle, seen at upper right, opted for a tree house on the swampy ground he selected for a site in Home, a demonstration of the choices available in the colony. His friend, Frans Erkelens, joined him in the project. They slept in the tree house and used the shed for storage. The tent-covered platform served as kitchen-dining area. A creek ran past the platform, providing a place to keep food cool and to wash dishes. Others in these 1909 photographs are unidentified.

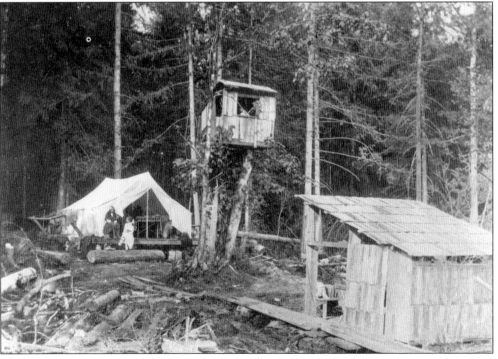

Nude bathing in Home occurred mainly among children. A mother gently reminded at least one girl who showed signs of maturity that it was time to wear a swimsuit. Some adults did indulge in swimming nude, but only under cover of night or after rowing out a distance before disrobing. People went to court and to jail on the issue of the right to bathe in the altogether. (Courtesy Sylvia Retherford.)

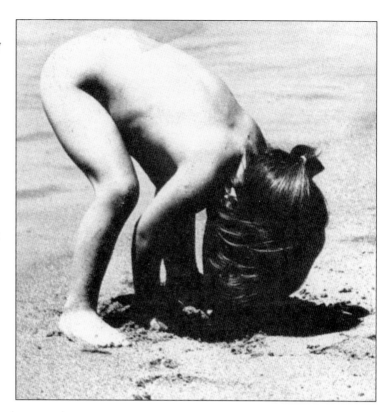

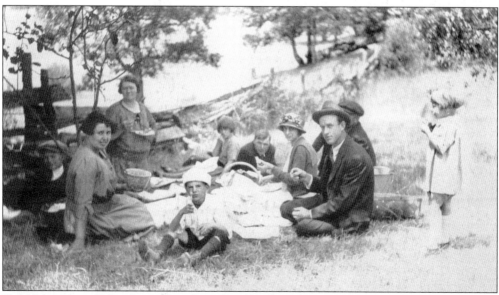

Ted Halvorson of Meridian enjoyed catching crabs and inviting friends to a crab feed. The Halvorson, Hademan, and Dadisman families share a crab feast in 1924. Chester Dadisman sits at center front, and his sister, Evelyn, stands at the right. (Courtesy Chester E. Dadisman.)

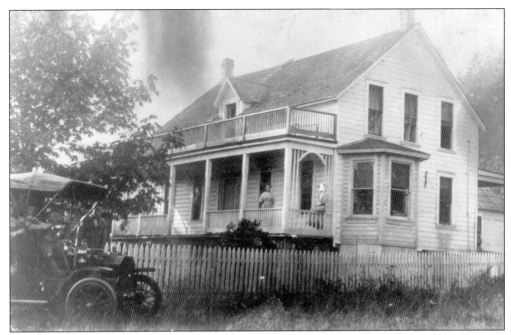

Henry Tiedeman, first Lakebay postmaster in 1882, built this home 10 years later, about the time he retired from the post office. Known as the Sorenson home most of its life, it burned in 1970 as part of the local fire department training program, a gift from then owner Denver Yates. The Lakebay Post Office was the first on the peninsula.

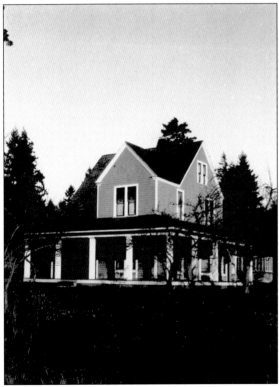

Alfred Van Slyke built this home on Vaughn Bay with lumber from his mill. Grandson Harmon Van Slyke, who grew up in this house, now lives on this site but in a different home. Six Van Slyke descendants live on Van Slyke's original property. (Courtesy Harmon and Jane Van Slyke.)

Nellie Van Slyke helped her father, Alfred, with the store and post office. When steamers could not come into the dock because of low tides, she rowed past the sandspit to get mail from them. She sometimes had difficulty rowing back through the channel against the current. She and her husband, Frank Holman, were the first to use the log Vaughn schoolhouse as a home. She lived to be 101.

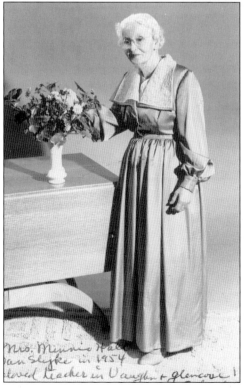

Mrs. Minnie Hall
Van Slyke in 1954
loved teacher in Vaughn + Glencove !

Minnie Hall began her marriage to Chester Van Slyke with a ride behind an orca (killer whale) harpooned in Vaughn Bay. Two young men looped a rowboat rope over the harpoon. The orca towed the string of connected rowboats out to Case Inlet before it freed itself. The somewhat shaken wedding party continued to Allyn. This 1954 photograph shows Minnie Van Slyke at age 83. (Courtesy Dulcie Schillinger.)

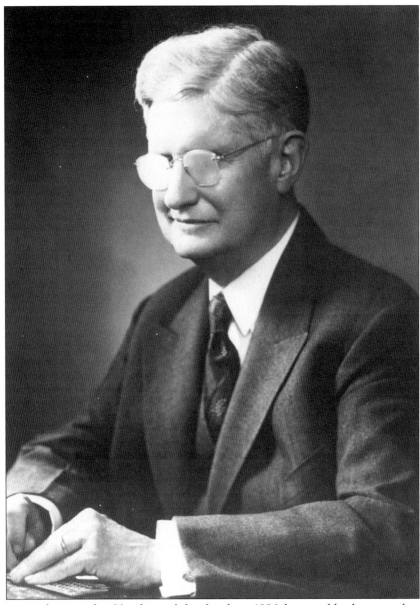

Robert Irwin, who moved to Vaughn with his family in 1886, became blind as a result of scarlet fever complications at age five. He attended the School for Defective Youth in Vancouver, Washington, and became the first blind graduate from the University of Washington. He rode a tandem bike with a friend as guide from Bellingham, Washington, to Jefferson, Oregon, selling mending solder and stereopticon views to earn money for college. Irwin developed an efficient Braille printing machine, created "talking books" on 33 1/3 rpm records, and organized a 1931 world conference for the blind. He helped pass legislation to give employment to the blind and wrote and helped pass the "bill of rights for blinded veterans." He returned to Vaughn with his family at every opportunity throughout his life, even after they moved to eastern Washington. The family rented a house in Vaughn for an extended stay whenever he visited from his New York home. They attended several of the annual gatherings of previous settlers. (Courtesy Hall of Fame for Leaders and Legends of the Blindness Field.)

Henry Hansen emigrated from Germany to the United States at age 16. He stayed with a relative in Minnesota until he learned enough English to get out on his own. Raised on a farm, he was curious to know if the soil in this area would support a mixed orchard. Three Hansen children, who all stayed in Vaughn, were born in this house, built for the Maxwells, Hansen's wife's relatives. (Courtesy Mary Georgene Knudson.)

Sherman Davidson and his wife, Christine, remodeled the previous home on this site at the head of Vaughn Bay when another child was due in the early 1930s. David Dadisman, with help from his sons, did the work. It included a sunken living room and additional bedrooms. The Riley family lived there in the early 1900s. New owners added on. It is now a bed and breakfast. (Courtesy Peggy Davidson Dervaes.)

Nathaniel and Ella Davidson followed his parents to Vaughn and inherited the family farm on Lackey Road. Davidson held many different jobs, including teaching for a while in Vaughn. Ella worked hard to get the Vaughn Union High School organized. Active in the Vaughn Library Association and the Good Roads Club, she also bought a waterfront cottage to be able to "mother" some of the young teachers as well as students of the school. She lived to be 95. The Davidson home is a Washington State Centennial Home, built prior to statehood and maintained by the same family since then. One could see both Mount Rainier and the Olympics as well as much of Vaughn Bay from this home when it was first built. (Courtesy Peggy Davidson Dervaes.)

Robert Davidson (left), his brother-in-law Oscar
Billings, and father-in-law, Thomas Gabrielson,
pose for a picture sometime in the 1940s.
Davidson and brother Sherman of Vaughn
started Davidson Brothers Logging Company in
1925, which kept many people in Vaughn and
the surrounding communities employed for over
20 years. (Courtesy Peggy Davidson Dervaes.)

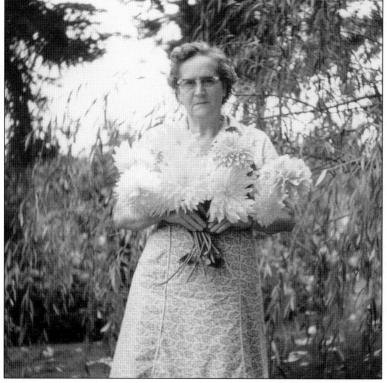

Bertha Davidson
holds a sample of
the dahlias she and
husband Robert
grew in retirement
years. The gate
stood open, and a
sign proclaimed,
"Aren't The
Flowers Beautiful?
Help Yourself
and Take Some
Home if You Like."
(Courtesy Peggy
Davidson Dervaes.)

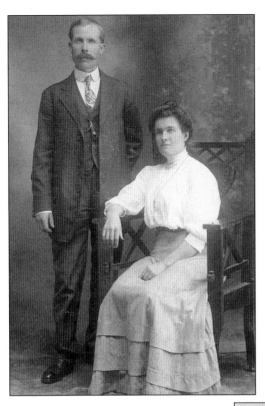

O'Gust (Olav August) Johnson (originally Jonsson) had learned some English, but his wife, Hilda, had not. He left her alone when he went to work. She asked what to do if someone knocked. He said, "Say you don't speak English and I'm not home." Hilda opened the door to a knock and said, "You don't speak English, and I'm not home!" The visitor departed. (Courtesy Johnson family.)

Maria Albertina (Jonsson) Lindgren, called Bertha, came from Sweden as a young woman and worked as a domestic until her marriage. She and two brothers followed brother O'Gust to Longbranch about 1910. Widowed after 22 years, she operated their farm with the help of her daughters, Violet and Jeanette. She cooked for the Longbranch School and started the coal furnace each morning before students arrived. (Courtesy Arlene Babbitt.)

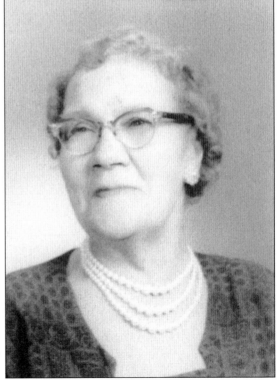

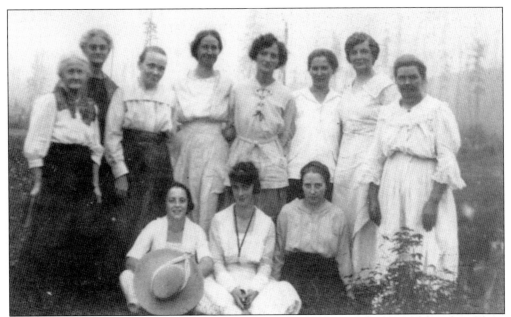

Women developed organizations like this Elgin Ladies' Club in many communities, whether it was a church ladies' aid, a ladies' club, or a social club. Meetings let them put aside housework to catch up on news and visit neighbors. Goals varied, but most served their communities by helping others, fund-raising for schools or churches, or contributing to the war effort when that need arose. Annie Davis stands at far left. Others are unidentified. (Courtesy Catherine Skahan Carlson.)

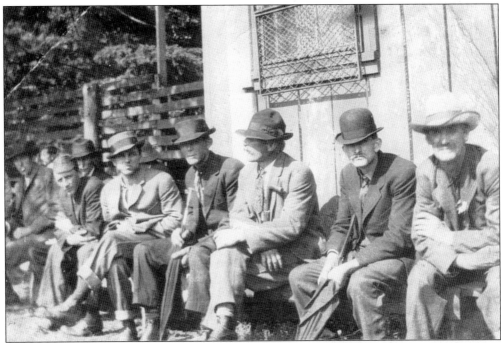

William E. White and sons sit with several other men at the White store in Wauna. From left to right are three unidentified, Mason White, John White, William E. White, Walter White, and unidentified.

Andrew Olson's farm near Key Center received a Washington State Centennial Farm designation, with continuous ownership by his descendents. Built about 1900, his home still looks the same outside and continues to be family owned. At 13, Elmer Olson, son of Andrew, drove a team of horses to help build a road across Olson property. Elmer and Elsie, pictured below, operated a chicken hatchery and a dairy, grew strawberries, bought huckleberries, and sold Christmas trees. He invented an electric huckleberry cleaner, still in use by his daughter, Joyce Niemann. The Key Center Huckleberry Inn was their former huckleberry shed. Elsie became the only "elected" mayor of Key Center in 1930, presented with a skunk cabbage bouquet. During the Depression years, she oversaw a government program in which neighbors made mattresses from surplus cotton batting and fabric. She lived to 100. (Courtesy KPHS and author's collection.)

Henry Moses Austin of England married Margaret Mary O'Neill, who emigrated from Ireland to the United States to work as a maid. They moved to Vaughn to farm, and that's where their daughter Esther met Glen Harriman. Austin's homestead later became the Fritz Jaggi home. (Courtesy Mary Georgene Knudson.)

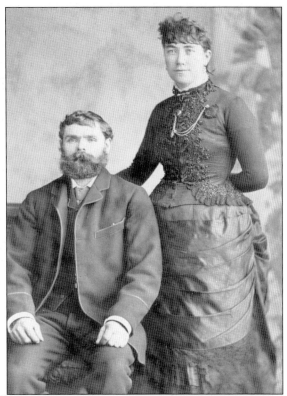

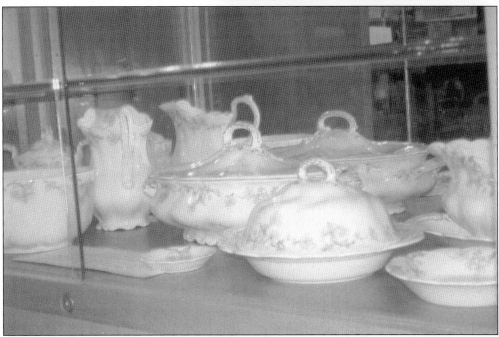

Ella Victoria Austin brought these Johnson Brothers Apple Blossom china dishes from Chicago in 1909 as a gift to her mother, Margaret Mary Austin. Margaret's granddaughter, Mary Georgene Knudson, donated them to the KPHS museum.

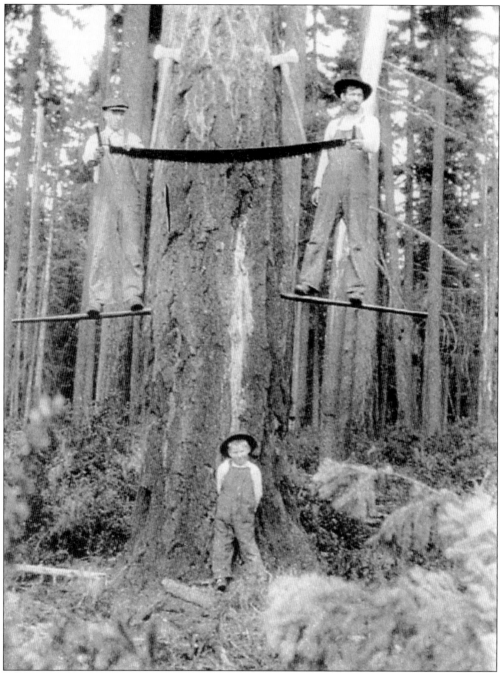

William Tillman and his father, James, stand on springboards with a crosscut saw, ready to cut a Douglas fir. Wedges may be needed to keep the saw cut from closing and to overcome the lean of the tree if it starts leaning in an adverse direction. The men did not push the saw but took turns pulling it. They applied just enough tension to keep it in place. The wood around the base of the tree tends to be gnarly to stand up to windstorms. The lower wood is hard to work, so cuts were made higher. Cutting crews usually kept a bottle of kerosene or light oil to cut the pitch and lubricate the saw blade. Wallace, eight, son of James, stands below in this 1918 photograph.

Four

LAND OF THE BIG TREES

Settlers who arrived on the peninsula in the 1800s looked for farmland and places to build homes, schools, and churches to form communities. They found shore-to-shore forests.

Logging became the essential first job. Many individuals and families cut their own timber and slid it to the bay to tow to mills.

Winchester set up logging camps at Minter, Glencove, Filucy Bay, Herron, Dutcher's Cove, and McNeil Island.

The Rainier family of Glencove logged extensively in the Minter areas and beyond, with a railroad to move logs to the bay.

Robert and Sherman Davidson started logging around Vaughn, expanded to the Rocky Bay area, and continued at various spots around the peninsula and beyond.

Harmon Van Slyke left Davidson's and started his own company with his father. His sons carry on the Vaughn Bay Lumber Company.

Logging companies helped support settlers and growing communities by clearing land, providing jobs, and purchasing local meat, produce, and dairy products. Steamers and schools needed wood, and enterprising men took on the job of supplying it. After trees fell, removal of stumps posed the next challenge. Men bored holes in the stumps, started fires in them, and kept them burning until they were ashes. Enough dynamite to obliterate a stump of virgin timber cost $2.50, which was the cost of an acre of land in the late 1800s, according to Sylvia Retherford, a third-generation Home resident.

Sawmills sprang up near most growing communities. The Purdy sawmill provided timber to build wooden dry docks at the U.S. Navy yard at Bremerton. A mechanic at the mill set up an extra saw to cut a bevel on the fourth run of the mill carriage to save time, and the mill underbid the competition.

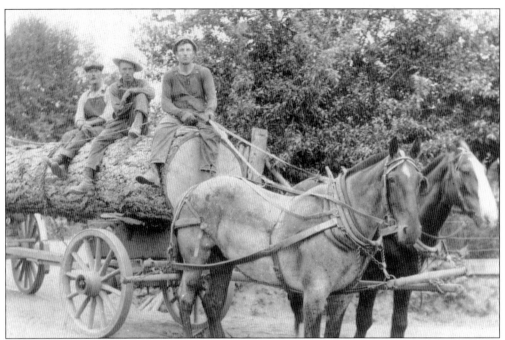

William King, Walter King, and Harry Dadisman haul a large log near Home in the early 1920s. The Home colony platted the land, offering one or two acres to all new residents, one for a home and one for gardening. They worked together to clear land and build on it. (Courtesy Sylvia Retherford.)

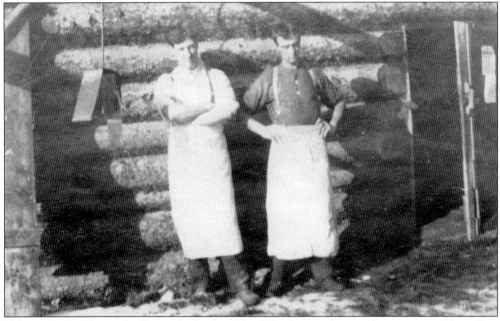

Two cooks stand outside the cook shack of the Winchester floating log camp at Filucy Bay. Portable logging camps with rafts and scows tethered at the shoreline for the duration of a job moved easily to new sites. Rafts carried cook shacks, bunkhouses, and stores. Mr. Emms, a cook, stands on the right.

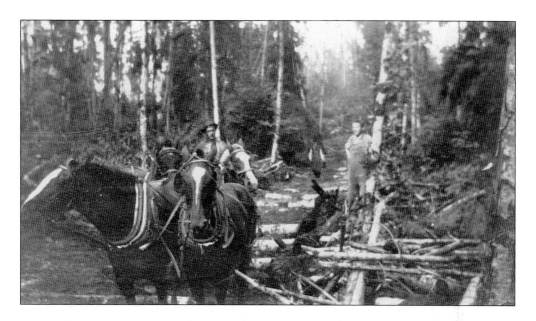

Early loggers on the peninsula used horses to skid logs out of the cutting areas. After trees near the water were cut, loggers built skid roads so horses and oxen could help skid logs from sites farther away from the water. The skid road in this picture extends up the draw to the right of the team. In the lower posed photograph, horses pull and guide the oxen forward. Two fallers have their cut started on a cedar. Vaughn storekeeper Harry S. Coblentz took this picture at a logging operation near Vaughn in the 1890s.

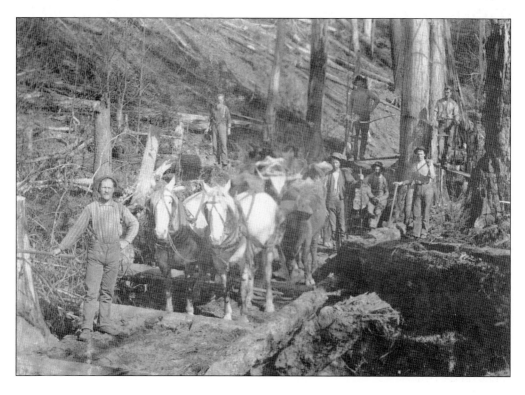

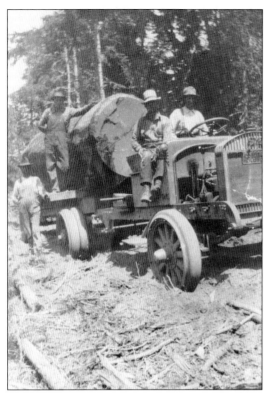

Elwin D. Nichols drives the GMC in 1916, with Robert "Bob" Niemann beside him; Mike Gryoreck is next to the truck. The other man is unidentified. Nichols operated a logging company and farm from his home, near Glencove. In the picture below, he stands with an unidentified man in front of a one-log truckload.

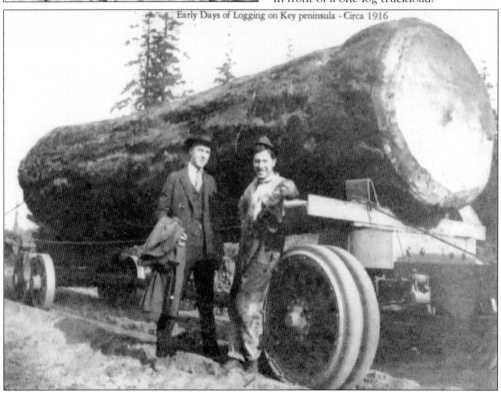

Early Days of Logging on Key peninsula - Circa 1916

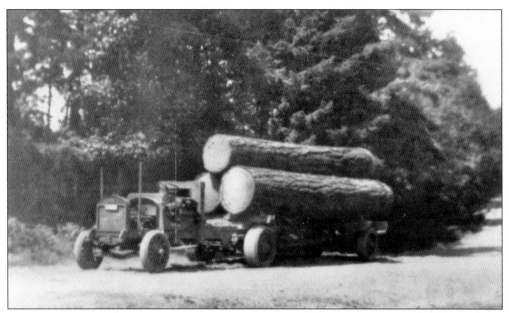

A Nichols truck prepares to unload a nice three-log load of Douglas fir at the log dump at Glencove in 1921. The dump was located near Camp Seymour, the first peninsula recreational-camping facility. Douglas fir, western hemlock, and western red cedar are evergreen tree species native to the peninsula.

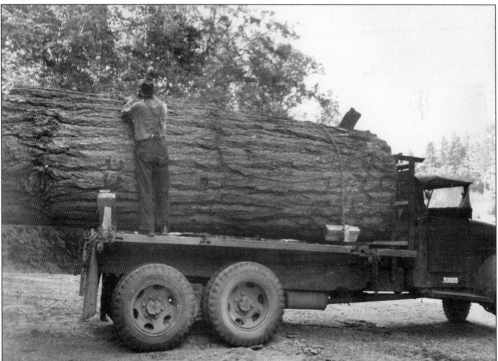

One log of old-growth timber made a truckload about 1939 near Vaughn. The man, not much taller than the tree's width, is unidentified. This was an uncommon find. Cut 10 feet above the ground, this beauty measures more than 5 feet in diameter. (Courtesy Dulcie Schillinger.)

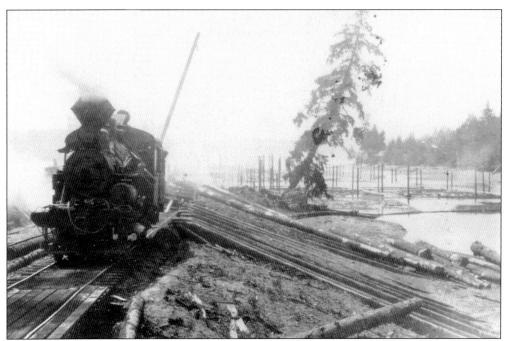

An Upper Sound Logging Company locomotive works near Vaughn in 1919. The company operated from 1914 to 1919 at the upper end of the peninsula. The tracks ran from near Carney Lake to the head of Vaughn Bay. The railroad grade can still be identified on some private property. One of the logging-camp bunkhouses, moved behind the service station at Vaughn by John Wolniewicz, became the post office for 14 years and then had multiple uses, including a barbershop and beauty shop. Below, visitors inspect the locomotive.

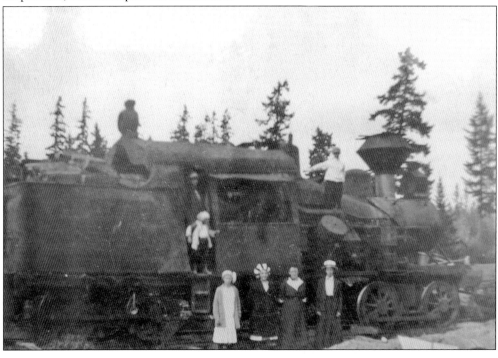

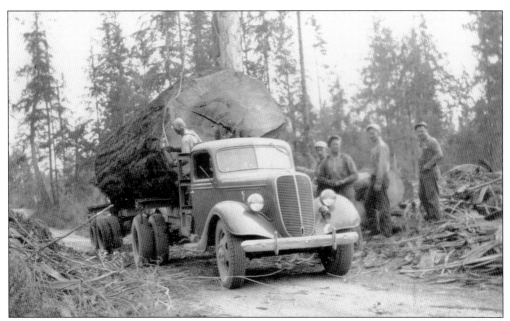

The crew needed to tend this big log with care. The spar tree that supports the rigging to lift the logs stands behind the truck in the center of this picture. One sizable tree on record provided eight logs and 41,000 board feet of lumber. The largest stump found on the peninsula, figured to be 1,785 years old when cut, bore signs in the 1950s reading, "Washington's largest stump" and "22 ft dia [diameter]."

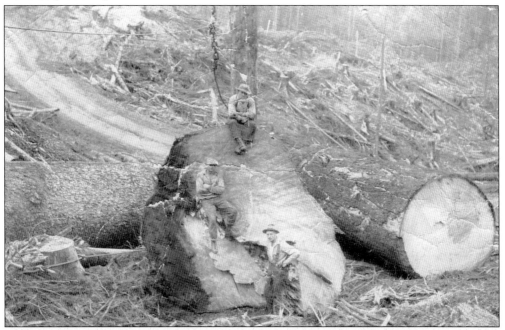

The log dwarfing the men in this picture looks like a Sitka spruce, such as those Boeing used to build airplanes for World War I, although spruce is not native on the peninsula. These logs appear to have been high lead yarded to the road, with the spar tree across the road and the butt rigging hanging in the top center of the picture.

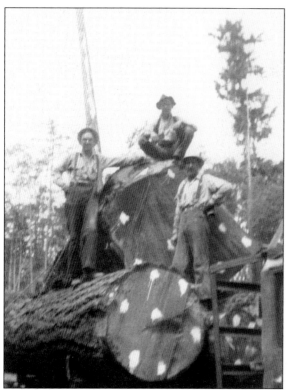

Nick Boquist, Lee Nelson, and Windy Williams pose on a good load of Douglas fir. Paint daubs usually indicated ownership. Those who came from the plains of the Midwest or eastern cities enjoyed having pictures made of their huge trees to send to friends and relatives back home. Many such photographs became postcards. Boquist's grandson Dale enjoys showing off his logging skills and steam donkey at local events.

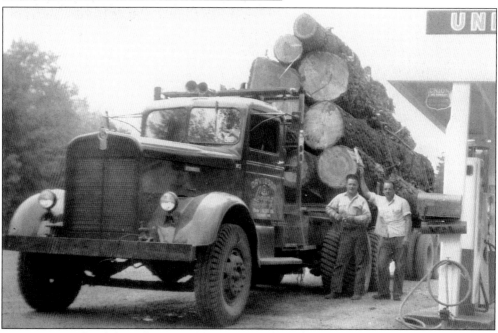

Don Janice and Ralph Collins stand between a Davidson Logging Company truck and the Collinses' service station/store in the 1940s. Collins's parents, James and Ruth Collins, built this station in Elgin soon after Highway 302 opened in 1923. The building now houses several small businesses.

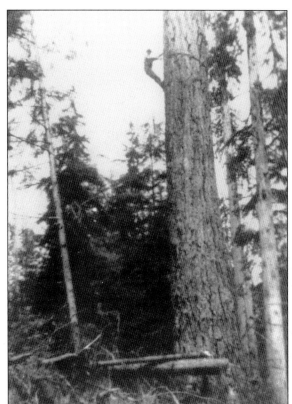

John Larson, age 21, tops a spar tree near Hoodsport in 1936. Only a few men chose to do tree topping, a specialized skill. High climbers topped and rigged spar trees for high lead logging, a distinct advantage over the skid road. One of Larson's longtime partners was Rogner Johnson, son of O'Gust Johnson. Below, Larson, still logging in 1972, said that most of the old-growth trees were logged off the peninsula by 1940.

John Larson

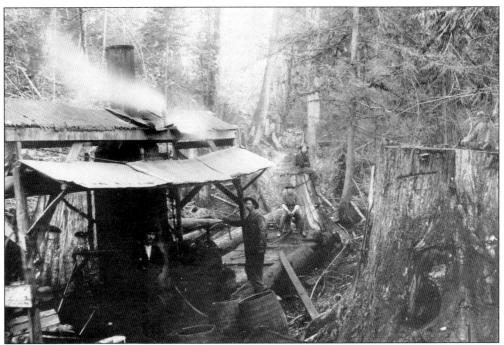

A steam donkey skids logs down a skid road. Steam donkeys increased efficiency. They were faster and more reliable than horse or oxen teams. Often loggers still used a horse to pull the line back out into the woods for the next turn.

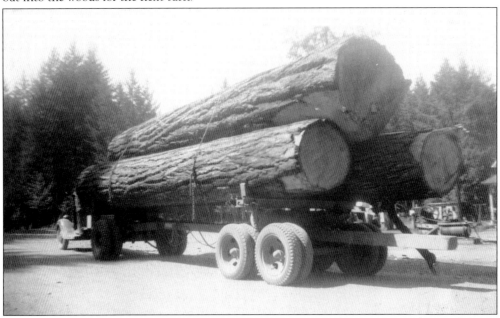

A nice load of logs goes down the road in 1947. In the summer of 1951, Jessie White and Grant Larson logged 20 acres of the Herron property White inherited from his grandfather. They had a contract to cut 150 utility poles 100 feet long. They felled, peeled, hauled the logs to the water, and made rafts—all using just two bulldozers and a 1936 log truck without brakes. Their pay that summer came to $11,000.

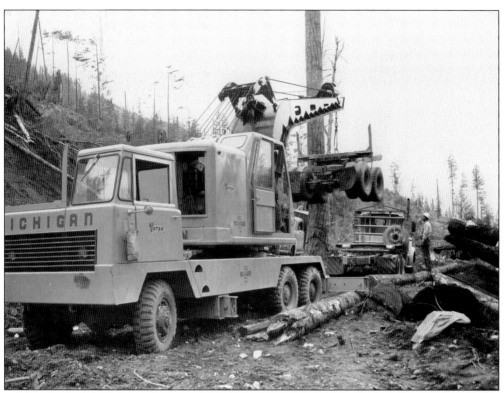

A Michigan Model T24 truck crane with a heel boom owned by Davidson Logging Company unloads the logging trailer. Trailers were loaded on the truck for the return trip to the woods. This saved wear on the trailer and took less fuel. (Courtesy Peggy Davidson Dervaes.)

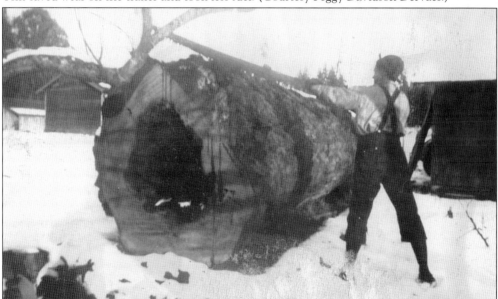

John Larson bucks a hollow Douglas fir that will make good firewood but not lumber. Like other loggers before and after him, Larson took advantage of what was available. Many early settlers who wanted farmland more than income burned their cut trees as waste.

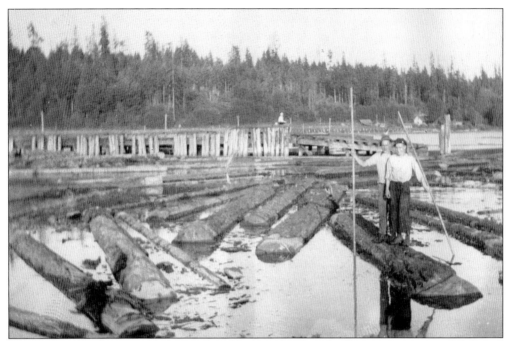

John and Ernest Matson work the logs in Glencove. Walking the floating logs required skill, and dunks in the drink were not uncommon among novices or inexperienced boom men. Smaller logs were used for boom sticks to be fastened end-to-end to contain the large logs for towing to the mill. (Courtesy Pearlita McColley.)

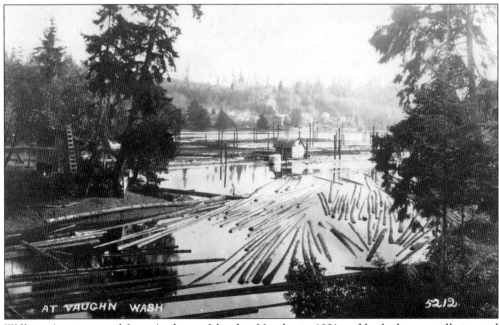

AT VAUGHN WASH 5212

William Austin moved from Anderson Island to Vaughn in 1921 and built the sawmill pictured at left in this photograph. He employed four or five men and provided lumber for many homes in the area. Austin maintained the mill until his death in 1939. Charles O. Austin, a son of William, had a longtime operating mill in Gig Harbor. This is Vaughn Creek and Bay.

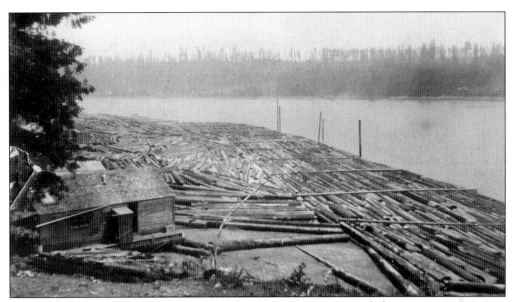

Logs in bays were a common sight in the early 1900s. The water provided easy transport, sorting, and temporary storage for the logs. Bandi Corner in Vaughn Bay received its share of logs to be rafted to a mill. The structure on the raft was likely part of a floating logging camp. (Courtesy Harmon and Jane Van Slyke.)

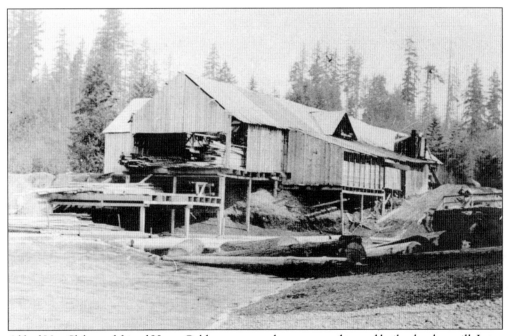

Alfred Van Slyke and friend Harry Coblentz operated a store together and built a lumber mill. Later Van Slyke ran the mill, and Coblentz the store. The Reverend Leigh Applegate, an Episcopalian minister, bought the mill from Van Slyke as well as land for a church. Applegate brought in improved equipment for the mill. (Courtesy Dulcie Schillinger.)

Alfred Van Slyke stands near the waterwheel on the creek above his sawmill. Most mills were sited on a protected cove, and the cove was used as the millpond. When a fire destroyed the mill and bankrupted Applegate, he sold it back to Van Slyke and left the area.

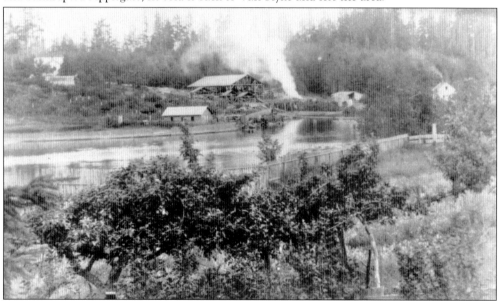

German immigrant Carl Lorenz traveled from Tacoma to the peninsula in 1882. On his first glimpse of Mayo Cove, Lorenz knew that was where he wanted to live. With help from neighbor James W. C. Ulsh, he hand dug the creek to deepen and widen it from Bay Lake to Mayo Cove. He built a water-powered sawmill and entered the lumber business. Ulsh and his son both used Lorenz lumber to build their homes. One is at the far right in this picture.

The Austin Mill in the background still looks like it's in good shape in 1944, and the Visell children and friend play near the water on Vaughn Bay. Gerry Visell sits in front of the girls, who are, from left to right, Judy Visell, Deanna Kovak, and Arlene Visell. By 1950, the children were older and the mill was rotting and falling. The children below are, from left to right, Gerry, Arlene, and Judy Visell. Their father, Don Visell, bought the mill property after Austin died. (Courtesy Judy Bradshaw.)

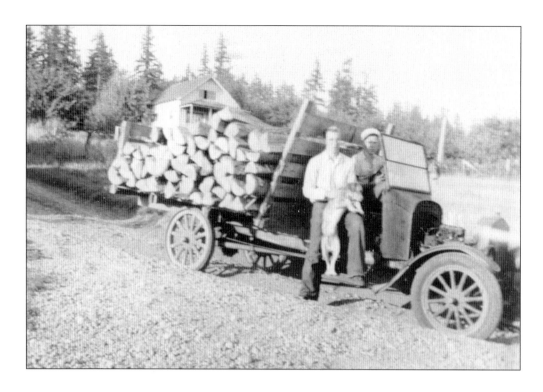

Ralph and Howard Kingsbury cut wood for the Vaughn elementary and high schools on contract in 1936. They paid 25¢ per cord on the stump and received $3 per cord delivered and stacked. Their father, Gordon Kingsbury, lost his shirt when his chickens developed coccidiosis so he needed to develop new sources of income. He bought a truck and hauled logs and Christmas trees, as shown here in 1936. (Courtesy Hazel Kingsbury.)

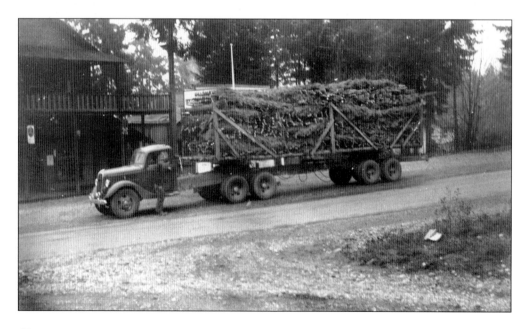

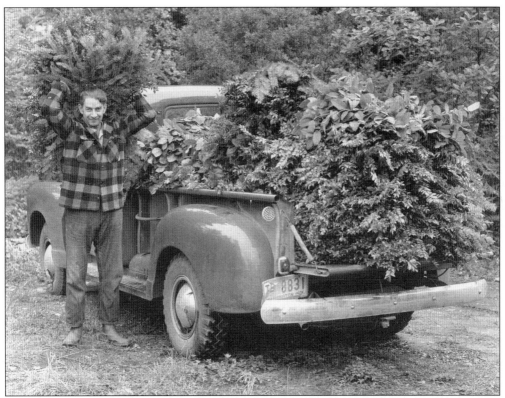

Brush picker Dewey Rodman of Vaughn demonstrates how they carried the greens from the woods in 1950. Pickers cut and carried sprays of evergreen ferns, salal, cedar, madrona, willow, fir, Oregon grape, and huckleberry foliage for the florist trade. Packers sorted, trimmed, and prepared shipments for businesses across the country as well as for local markets. (Courtesy Dulcie Schillinger.)

Elmer Skahan picked brush for 60 years, as did his wife and children. He built this brush shed after marrying Helen Lunore Day, whose family home was on third-generation acreage in the Minter/Elgin area.

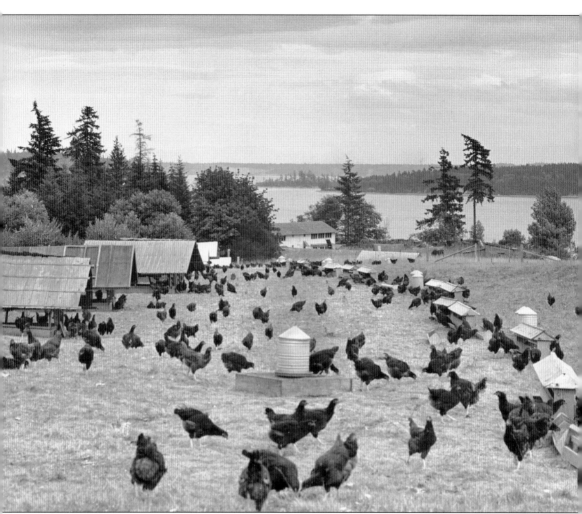

These Rhode Island Reds, grazing at Taylor Bay near Longbranch, were raised with free-range pasturage and movable "colony houses," something new in this area in the late 1940s. Chicken farming became one of the early local industries. Almost everyone raised chickens, whether for their own use or to sell the eggs and/or poultry. Home Warehouse hired egg candlers and packers. The warehouse shipped 1,600 cases of eggs to Seattle a week. One man's daily job was constructing egg crates. David Dadisman obtained slabs from Austin's mill for the crate making. Two chicken hatcheries operated on the peninsula. In the 1930s, some occurrences of coccidiosis, a fatal chicken disease, as well as competition from larger commercial concerns, eliminated chicken farming as a viable industry in the area. (Courtesy Dulcie Schillinger.)

Five

AGRICULTURE, COMMERCE, AND MORE

Orchards and gardens became high priorities. Apples, cherries, pears, plums, prunes, and quince provided fresh and dried products to ship out on local steamers. A farmer from Herron said dried prunes were added to tobacco products for improved flavor, but much of the fruit was shipped to Alaska for sale to gold prospectors. Competition from large fruit growers in eastern Washington ended the profitable fruit enterprises on the peninsula.

Vineyards grew well in certain sunny areas of the land, as well as on Eckert Island (now Stretch Island), to the west of the peninsula. A settlement named Detroit became Grapeview, and the Eckert winery prospered there for many years. Adam Eckert developed the popular Island Belle grape.

Gottlieb Stock started a winery at Rocky Bay in 1935 and purchased additional grapes from Edward Buckell of Vaughn, William Schillinger of Victor, and some Longbranch vineyards. His wines sold only in Washington. California wines could not be sold in the state, and local wineries flourished until other wines were allowed in during the 1950s. In recent years, two winemakers have begun peddling their wares on the peninsula. One specializes in non-grape wines such as berry and rhubarb.

Work bees, whether to build a house or get in the hay, turned into social occasions, with women providing food and children renewing friendships.

Friederich Raasch, Carl Lorenz, and Louis Hiller operated the Meridian Brickworks. Hiller recruited friends and relatives from Wisconsin, including the Summerfelts and Rickerts, to work for him. They furnished bricks for Union Station and the old St. Joseph Hospital in Tacoma. Seattle and Tacoma required large numbers of bricks for paving the main roads. Harry Winchester learned the art of brick making from Raasch and set up his own brickworks at Glencove. It was later operated by Nicholas Petersen.

Carpenters worked as much as they wanted, as did early storekeepers—once they stocked their shelves and barrels. The Bradley home in Vaughn included a bakery in the basement. Schools needed teachers; mills and brickyards needed workers; and boats needed crews. Willing workers found jobs that needed doing, and peninsula folk survived hard times.

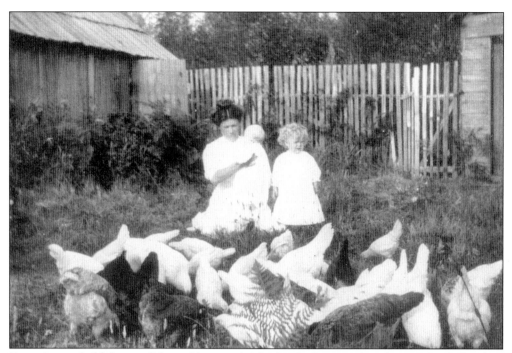

Fanny Larson holds her son John as Virginia checks the chickens on their farm in "Little Sweden" on Lackey Road, south of Vaughn, in 1913. When electricity arrived on the peninsula, the poultry houses often received wiring before homes. Some chicken houses were two-story affairs. To those coming in on the boat at night, Home and Lakebay looked like cities because of the chicken-house lights, said Henry Ramsdell. Below, longtime turkey farmer Theodore Knudson introduces Lackey Road neighbor Peggy Davidson to his flock. Later introductions on the peninsula included ostrich farming. (Courtesy KPHS and Peggy Davidson Dervaes.)

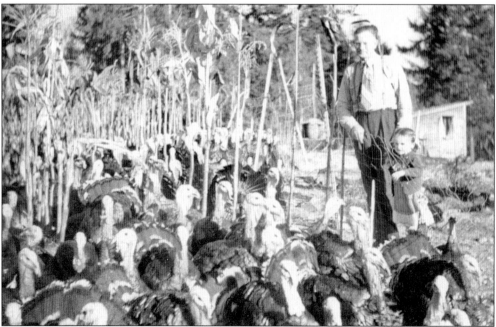

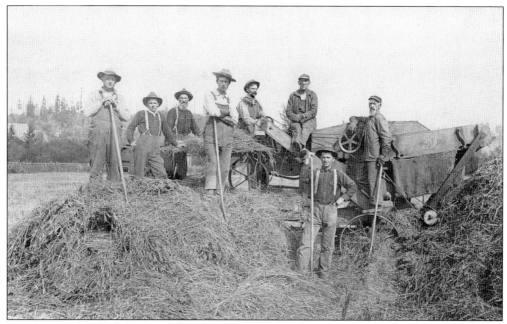

Members of the Curl family of Longbranch and their friends make hay in the 1930s. Several generations of Curl families became involved in the community, including being active in the Longbranch church. Henry's wife, Ida, donated land for the current Longbranch Fire Station. Their daughter Marguerite and Raymond Bussard became the first couple married in the Longbranch Community Church.

Photographer Chester Van Slyke captured a serene scene in rural Longbranch in the 1940s. The Longbranch Community Church is on the right. The Curl acreage is at the back. The long roof to the left covers the Longbranch Improvement Club. Built in 1939 as a WPA project, it was the Longbranch school gymnasium. (Courtesy Dulcie Schillinger.)

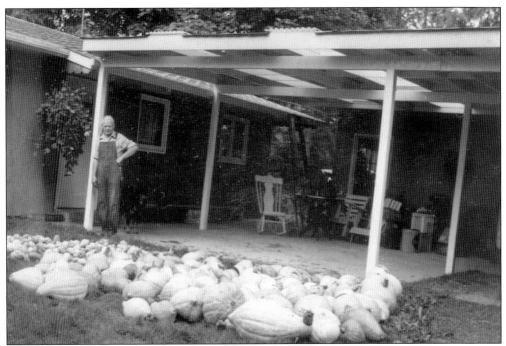

Glen Harriman carried on the gardening tradition of his father into his later years, seen here in 1958 with his squashes and gourds. His father, Louis, planted the first vineyards in Vaughn. Their land faced west on Case Inlet. (Courtesy Mary Georgene Knudson.)

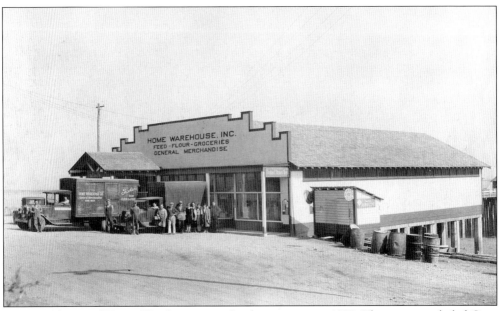

Some employees of Home Warehouse pose for their picture in 1928. This group included Cora Fox, Fred Guse, Hilda Larson, Bertha Lonning, Kully Movall, Ernie Nordquist, Ed Padgem, John and Clarence Schultz, and Elgin Williams. David Dadisman managed this company for many years. (Courtesy Chester E. Dadisman.)

David Dadisman became a justice of the peace and managed the Home baseball team. He bought a 1922 Dodge, one of the first cars in Home. Neighbors asked for rides when he headed to town to shop. He soon put up a sign that read, "Notice! You are welcome to ride in this car, but you do so at YOUR OWN RISK. D. Dadisman." (Courtesy Evelyn Dadisman Evans.)

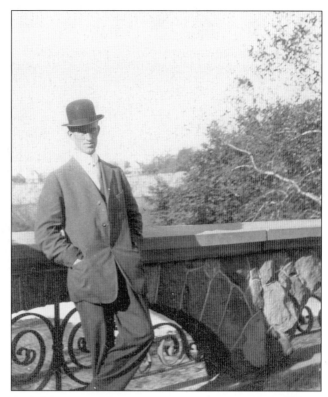

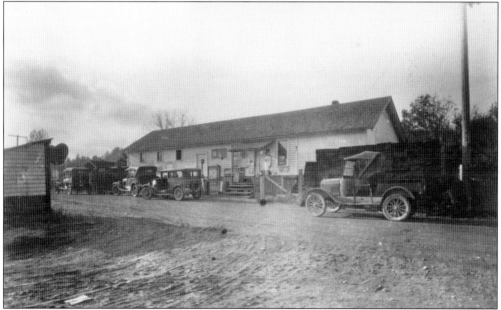

Dadisman managed this store, shown here about 1926. The family lived in the right end of the building. It consisted of two rooms, although, by the time of this photograph, Dadisman had enclosed the porch for a sleeping room. The Dadisman children were free to explore but forbidden to help themselves to any goodies, as their father did not own the store. (Courtesy Chester E. Dadisman.)

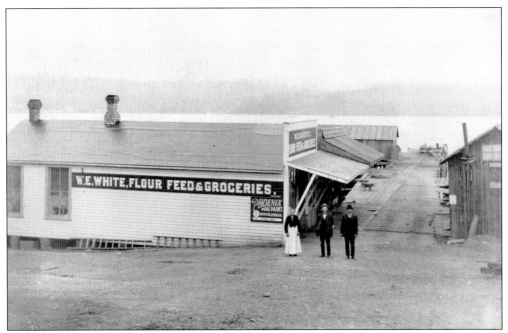

William E. and Mary Frances White started their Wauna store on the upper side of the road. Boats docked to carry passengers, mail, produce, and supplies, so they built this 1906 store on pilings in the water. The Wauna Cardroom and Smokehouse, a shack where men met for talk and games, was next door. The Whites are in this picture with an unidentified man.

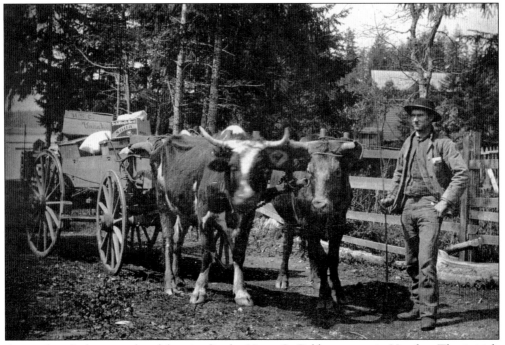

An unidentified man makes deliveries for the Harry S. Coblentz store in Vaughn. The initials H. S. C. are visible on one box. The bay can be seen in the background. Coblentz took the picture, which dates it to the late 1890s.

Robert P. Irwin bought five acres for $5 from Ella Maxwell for a cemetery about 1894. He laid out the plots and sold the parcel to the Bayview Cemetery Association for $125 in 1915. William and Annette ("Uncle Billy" and "Aunt Nettie") Davidson sold two acres for $1 to the association. This became Vaughn Bay Cemetery because a Bayview Cemetery already existed in the state.

Friends gathered at Irwin's home include Minnie May Thaler, Minnie Hall, Lettie Hastings, and members of the Sherman family. Irwin, the first licensed pharmacist in Washington State, was also postmaster and storekeeper in this building. He served as justice of the peace for Vaughn.

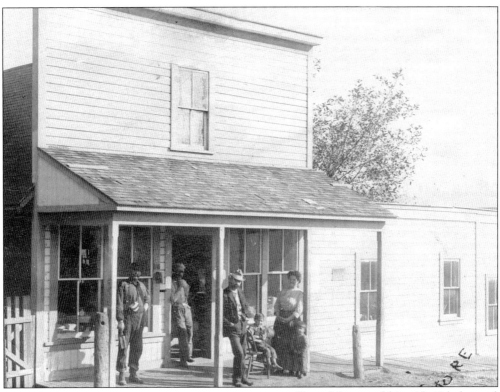

Harry Meyer and his wife, Ethel, stand outside the Longbranch Mercantile in 1902, with Charles Larson on the left and Cordy Doolittle in the doorway. The two younger children are likely Ray and Edna Meyer, and the boy in the chair unidentified. Morris J. Bullis built the store, which changed hands many times. Meyer built the adjacent warehouse, where dances were held. Carl Soderquist named it the Mercantile under his ownership.

Frank L. Bill managed the Upper Sound Grange Co-op store at Vaughn, on the walkway to the dock. A charter member and treasurer for both Upper Sound Grange and the Vaughn Bay Cemetery Association, he moved to Vaughn from Alberta, Canada, in 1911 with his wife, four children, and his parents. He was a carpenter, butcher, farmer, and crack shot. A garage he built about 1920 still stands. (Courtesy author's collection.)

Alden E. Visell built a hardware store with a lumber shed and the first grocery store in Key Center in 1931—the beginning of a peninsula business center still in existence. He managed the hardware/lumber area and let others run the store. Other 1930s businesses included Gabrielson's service station, Olson's huckleberry shed, and a tavern. Leah Hipp stands outside the store, then owned by her and husband, Chester. The store included a butcher shop, 350 frozen-food lockers, and a liquor store. The whole complex burned to the ground in February 1970. They rebuilt stores but with separate buildings. More than 30 businesses now operate along both sides of the Key Peninsula Highway in the area called Key Center. (Courtesy Judy Bradshaw, KPHS.)

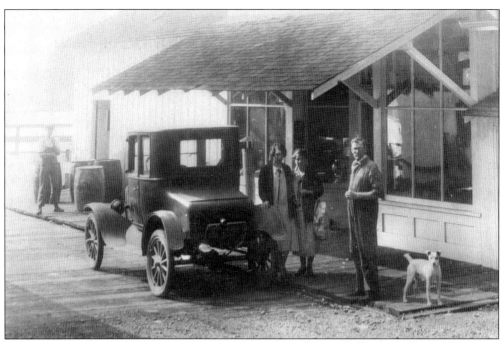

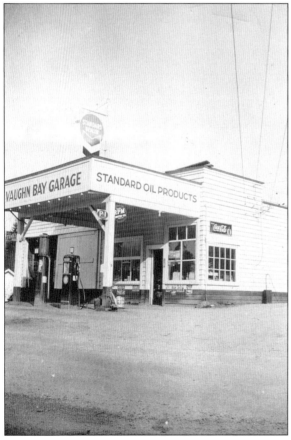

Lyman E. Freeborn; his dog Tug; his wife, Margaret; and daughter Geraldine stand next to Ed Gabrielson's Model T Ford in 1925. Freeborn bought this Vaughn store from Van Slykes in 1920 and assumed postmaster duties soon after. He and son-in-law Robert Stratford moved the store and post office from here to the former Wolniewicz garage (left) as a better business location about 1950. Gordon Kingsbury and John Wolniewicz built the first Vaughn garage on Kingsbury's property. They built this one at the crossroads of Vaughn, a more central location. Wolniewicz towed people as needed, provided mechanic services, and did whatever he could for the community. When the garage burned down, they saved the pumps, and the community helped rebuild the structure with Austin mill lumber, putting Wolniewicz back in business. (Courtesy Dulcie Schillinger, Helen Wolniewicz.)

Henry Dahl built their Victor home with a large garage on one side, installed gas pumps, and ran the Coulter Creek service station for several years. Grandson Howard painted a replica of the station on the side of his Tacoma garage so family members can continue to visit their family service station.

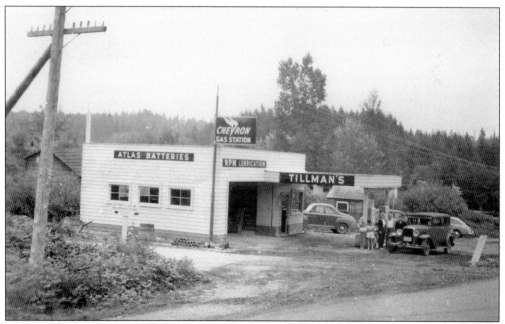

Cars arrived on the peninsula, and soon most communities had gas stations built by the side of the roads to accommodate them. Some, like Wallace and Virginia Tillman's in Home, pictured in 1947, included a service garage. Doris Tillman, a niece, and her children stand with unidentified men. Harry Frishman's barbershop can be seen next door.

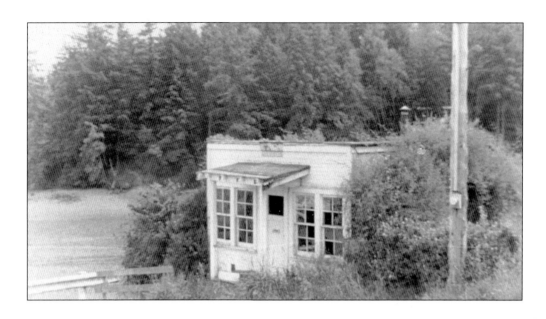

When Ernest Shellgren asked for a post office for the Filucy Bay area, the postmaster general said he needed an accepted name for the community. Edward S. Yeazell, a land speculator who owned much of the bay shoreline, suggested Long Branch, in remembrance of the New Jersey resort city. Due to confusion with Long Beach, Washington, the postmaster general changed the name to Longbranch in 1894. Shellgren set up a mail-sorting cabinet on his boat, the *Monte Cristo*, for the first Longbranch Post Office. Shellgren's post office, shown here in 1930, served for many years. Below, George Rickert, Ellen Shellgren, and Fred Guse enjoy some time in the fresh air. Ellen served as Longbranch postmaster for 40 years. When she retired in 1964, Longbranch became a rural delivery of Lakebay Post Office.

Albert Sorenson became the first rural-route mail carrier for Lakebay in 1909. The 22-mile route increased by 4 miles the next year, and to 72 miles by 1960, long after Sorenson married, resigned, and operated the Lakebay grocery. Before retirement, he moved up to a Model T Ford, one of the first on the peninsula.

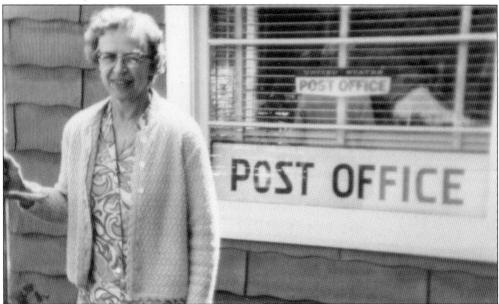

Bertha Mills, Vaughn postmaster for 19 years, moved the post office to its own building behind the store in 1955. Prior to that, the storekeeper would be the postmaster, or the postmaster would assist the storekeeper. Her tenure saw the new post office built in 1969. Mills's father, Emil Lonning, was Glencove postmaster for eight years, and her sister, Irma Nordquist, covered Lakebay for nine years. (Courtesy Don Mills.)

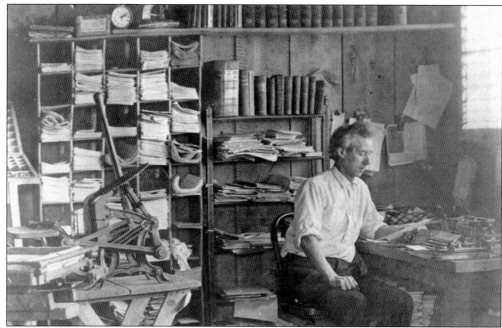

Home's Liberty Hall gave Jay Fox space for a printing office. Arrested because he encouraged disrespect for the law by arguing for nude swimming and free speech, Jay Fox, last of the anarchist editors from Home, spent six weeks of a two-month sentence in jail for publishing "The Nudes and the Prudes," in his newspaper, the *Agitator*. The U.S. Supreme Court refused to overturn the conviction. The governor pardoned him. *New Era, Discontent,* and the *Demonstrator* were other Home newspapers. Fox's ancient press is in the KPHS museum.

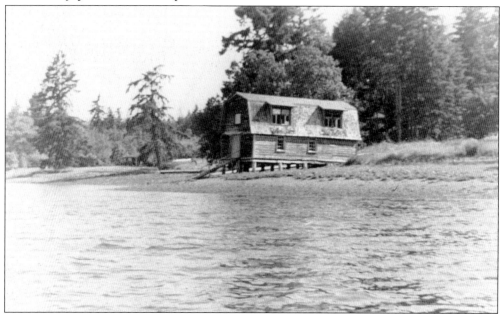

William Sipple's boatbuilding shed still stands on the shores of Filucy Bay. He also built furniture and houses, including his own, and Rose Briar Castle for the Buss family, a turreted home on a Longbranch hill. Sipple used maple burls to make violins and local woods for inlaid tables.

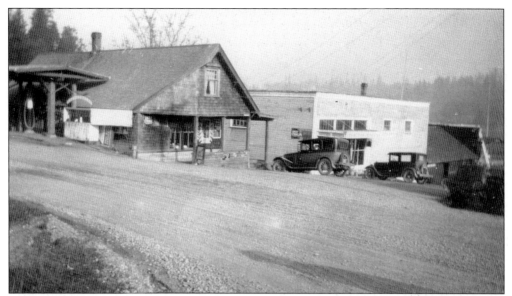

The building on the left housed Jesse Porter's establishment. He barbered, did radio repair, and sold candy, ice cream, cigarettes, and tobacco. Two pool tables plus tables and chairs for card playing brought in neighborhood men. Porter's wife, who lived to be 103, helped cook her own 100th birthday dinner. She mixed her own blend of tobacco, and as a boy, grandson Jessie White helped her roll her cigarettes.

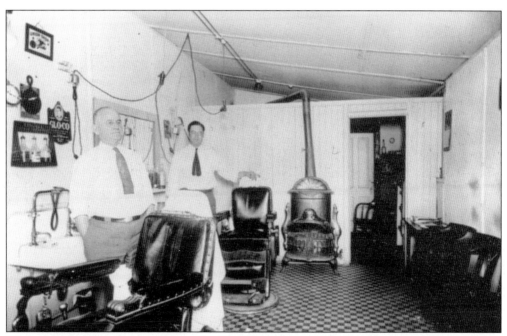

Warren Smith, grandfather of Jane (Bradley) Van Slyke, set up the first barbershop in Vaughn in the end of the warehouse by the dock about 1925. Jane's husband, Harmon Van Slyke, needed a large lollipop to convince him to get his first haircut there at age six. Smith later moved into a nearby separate building. (Courtesy Harmon and Jane Van Slyke.)

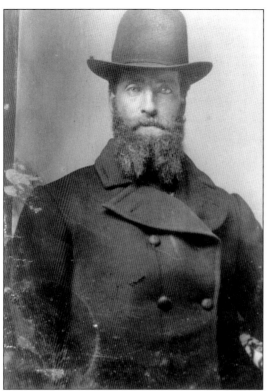

At age 52, Dr. John Alexander Hall's dream was to farm. He did some minor medical treatments in Vaughn, but his wife thought the community too small for major practice; people knew each other too well. Hall maintained good physical health, chopping wood every morning before a quick swim in the bay, regardless of weather or time of year. While clearing his land in 1894, a falling tree killed him.

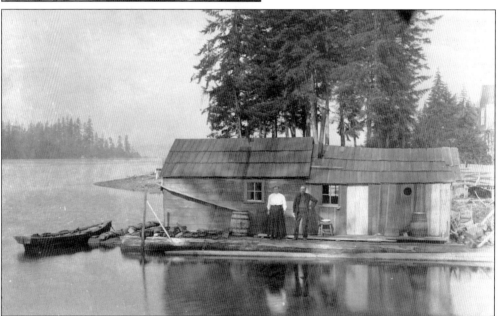

Howard M. Rodman and John G. Fox started an oyster-growing business in Vaughn Bay in 1900, planting oysters in most of the Vaughn tidelands. Men shucked and bottled oysters in this float house near the property Fox purchased from the Hall family. Fox took some oysters to Seattle bars for cocktails. The people on the float are unidentified. Descendants of both men have homes on their original properties.

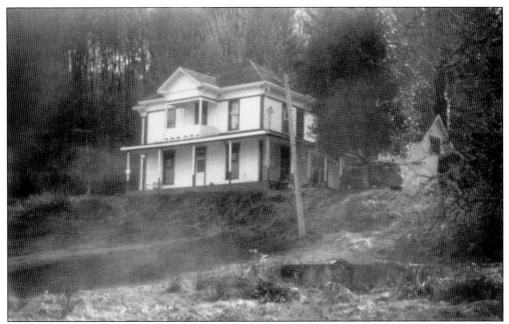

Hans Nicholas and Agnes Petersen built a hotel with six guest rooms on the hill above Glencove in 1897. Daughter Louise and her husband, Oscar Boquist, maintained it after the death of her parents until 1930, when the need for a local hotel disappeared. Current owners Larry and Luciann (Micki) Nadeau refurbished the building, and it was placed on the National Register of Historic Places in 1977. The above photograph, taken in 1976, shows the original exterior structure unchanged. The Petersens planted orchards and gardens, and produced most of their own food, including beef, pork, turkey, lamb, chicken, and duck. They smoked ham, bacon, and salmon. Agnes, the camp cook for Winchester, was a superb cook. Local Native Americans traded her a whole salmon for a couple of loaves of homemade bread.

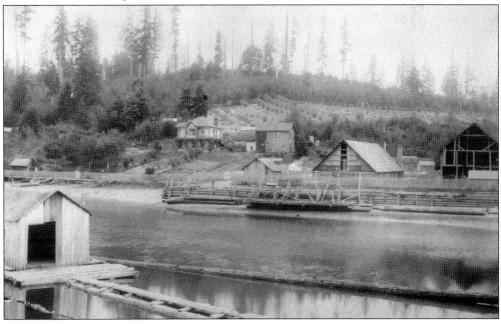

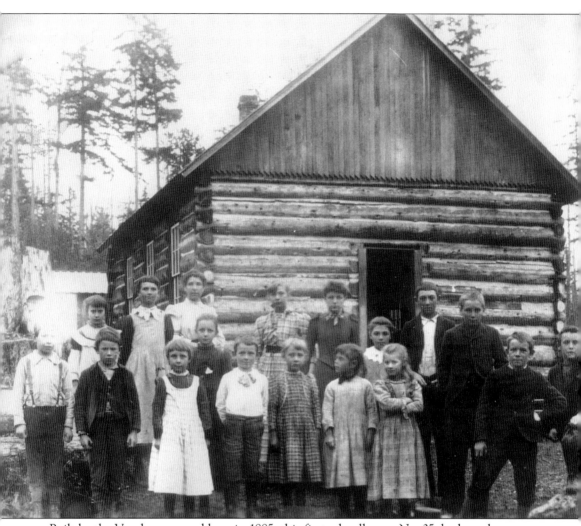

Built by the Vaughn men and boys in 1885, this first schoolhouse, No. 35, had one large room with a square of painted board for the blackboard. John Alverson donated land, and William Wright provided the logs. When two new schools replaced this one, it became a residence. Heavy log joists still support wide board floors. A portion of the original log wall is visible around the electric meter. A Royal Ann cherry tree, planted when the school was new, still survives at a corner of the house. Teacher Miss Huselby stands behind the students in this photograph, about 1893. Students are, from left to right, (first row) Fred Bliss, Lester Davidson, Clara Farley, Joe Coblentz, Edith Prater, Beaulah Peters, Anna Irwin, and Walter Hoit; (second row) May Bliss, Alma Alverson, Cora Van Slyke, Lora Prater, Nellie Van Slyke, Alice Alverson, Clarence Alverson, Devore Milbrand, and Eben Peters. The road was behind the school at this time. Only a footpath went from the store to the school, and a fallen log was used to cross Vaughn Creek when the tide was in.

Six

EDUCATION, CULTURE, AND RELIGION

Education often rated at the top of the list for new settlers with families.

Sarah Creviston married at age 14. Unable to finish her own schooling but determined to provide education for her children, she invited neighbor children into her home near Little Palmer Lake to start them on the basics.

The first school building on the peninsula, constructed of logs, housed Creviston's children and neighbors in 1878. By 1900, each community contained a schoolhouse, usually one room and one teacher. Students considered it a privilege to carry drinking water to the classroom, raise the flag, or lead the pledge of allegiance.

Early Longbranch students attended classes in the German Lutheran Church, the first church on the peninsula.

Lucinda Minter started school in her home. A later Minter teacher traveled to Rainier's logging camps to teach English to the Swedish, Danish, and German loggers. Wauna and Purdy's small schools took four-month turns so that each school could be maintained.

Clyde Davidson's memoir tells how squirrels toppled lunch buckets set on a bench in the cloakroom of South Vaughn School No. 94 and carried off food. They chewed through the closed door.

Upon completion of eighth grade, students who wished to continue their education traveled to Tacoma until Vaughn Union High School organized in 1903. Students and teacher met in the newly carpeted Vaughn church rectory but held school programs and graduations in Library Hall. Students numbered 16, including eighth graders.

In 1907, a one-room school took shape at the head of the bay. Four districts formed the high school: Vaughn, Rocky Creek, Glencove, and South Vaughn. By 1921, some students from Minter attended, and a few years later, they were joined by more from the lower peninsula and from Victor.

Volunteers, with help from WPA, built a new gymnasium in 1937. The men took great pride in their workmanship, and the floor still withstands heavy use today. This school served, with additions over the years, until 1947, when Vaughn and Gig Harbor merged to form Peninsula High School at Purdy. At that time, seventh and eighth graders from the lower peninsula attended Vaughn.

Cornelia Fletcher Hall came to Vaughn from Missouri by way of Texas and California in 1889. She received a post high school degree in language studies with high commendations from Ann Arbor High School in Michigan. Women were not admitted to the university in her day. The first teacher in the 1885 log schoolhouse of Vaughn, she became active in several organizations and was the first librarian for the Library Association.

Minnie Hall, daughter of John and Cornelia Hall, followed in the steps of her mother to become a teacher. She began teaching at Longbranch and also taught in Vaughn, Glencove, and at Vaughn Union High School. She enjoyed being historian for local organizations. This photograph was taken in 1904. She lived to be 87. (Courtesy Dulcie Schillinger.)

Lucy Goodman, an early teacher in Vaughn and Glencove, later taught in Gig Harbor. She retired from public school, and then started and taught the first kindergarten in Gig Harbor. She had taught longer than anyone else in the United States, a total of 76 years, when she retired at 93. Goodman Middle School in Gig Harbor was named for her.

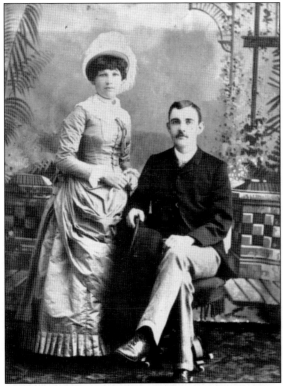

Sylvia and George Allen, married in 1884, opened a school in their tent a day after their arrival in the new community of Home. Ten children of the three families—Allen, Odell, and Verity—attended. Sylvia Allen was the first woman to graduate with a four-year degree from the University of Toronto. She named the new community they helped found "Home" because she was ready to settle down. (Courtesy Sylvia Retherford.)

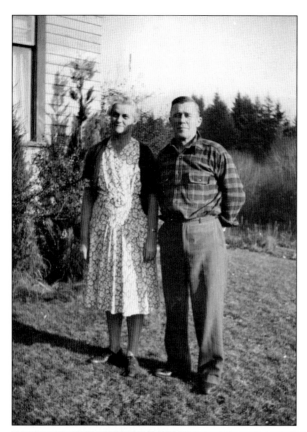

Byron McColley taught and was principal at Vaughn Union High School. His wife, Partha, shared her culinary talents at Glencove Elementary and later at the high school. They built a gracious home overlooking Glencove, and it is still a residence of the McColley family. (Courtesy Pearlita McColley.)

These students at Elgin School, about 1907, include Verne Lunore (1) and Margaret Davis (2), the parents of Helen Skahan, who still lives on original Davis property. Ace McCurdy remodeled the school into a home in 1925, and it is still a private residence. (Courtesy Catherine Skahan Carlson.)

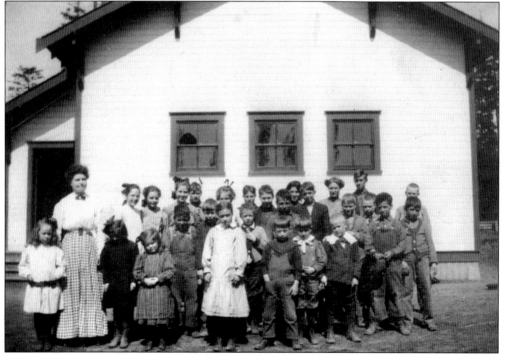

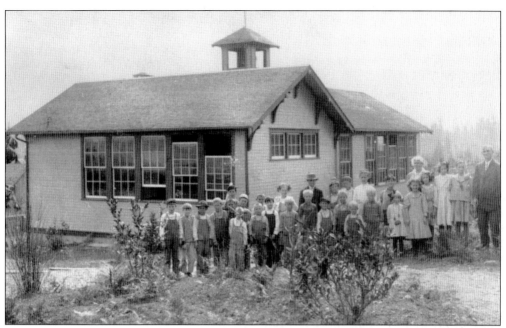

The first Home classes used a variety of spaces, including a tent, homes, community halls, and a small building near the beach. The second actual school building, pictured here with George and Sylvia Allen as teachers, is now a private residence. Home consolidated with Lakebay in 1924, and Longbranch was added in 1941. This photograph was taken about 1911.

The second Glencove School sat on the hill above the bay. Chuck and Sharon West refurbished it in 2003. Their open house turned into a reunion for nine former Glencove students, who asked if they'd raised the ceiling. The school, built about 1912, served grades one through eight until Peninsula District formed and consolidated several elementary schools in 1941. The original fir floor is still in place.

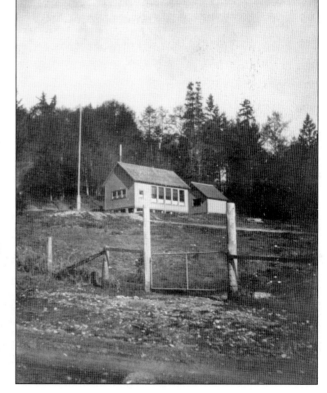

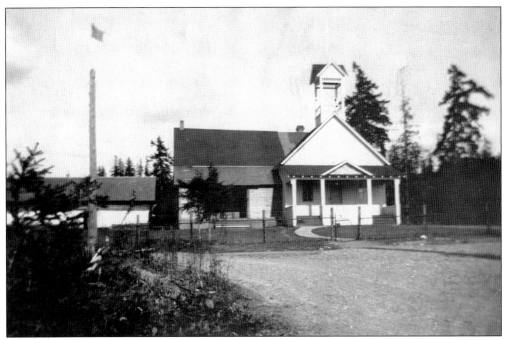

Vaughn Union High School No. 1 was the first rural Pierce County high school. The number became No. 201 to designate it as a secondary school. It is seen here in 1931, by which time a porch had been added to the original building. The building is now the Key Peninsula Civic Center.

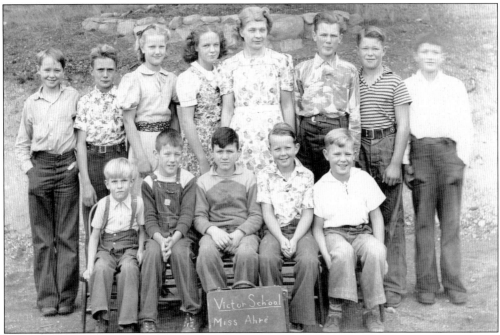

The annual picture for Victor in 1939 shows students of the one-room, eight-grade school. From left to right are (first row) Kenneth Esler, Tom and Kenneth Archer, James Dahl, and Dale Hager; (second row) Donald Dahl, Russell Schillinger, Audrey Hanson, Doris Hager, Teacher Ahre, Ronald Schillinger, Elvin Edwards, and Keith Archer. (Courtesy Ed Edwards.)

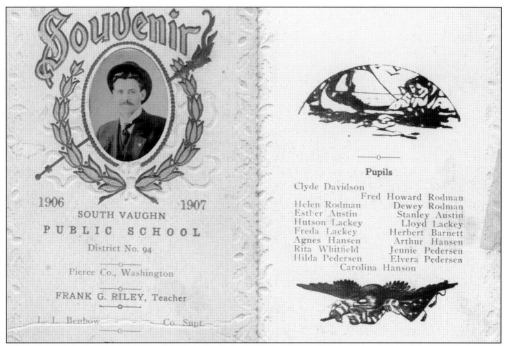

The 1906–1907 District No. 94 school souvenir noted Frank G. Riley as teacher. The trustees, called directors in 1908, were N. N. Davidson, Stanley Jones, and Anton Pederson. Riley later became a lawyer. His family lived for a time across the road from the current Key Peninsula Civic Center. (Courtesy Georgene Knudson.)

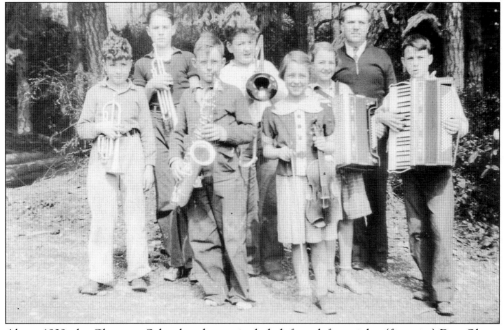

About 1939, the Glencove School orchestra included, from left to right, (first row) Don Olson, Warren McColley, Doris McColley, and Roy McColley; (second row) Billy Jack Hipp, Edmund Olson, Phyllis Olson, and Teacher Hupp.

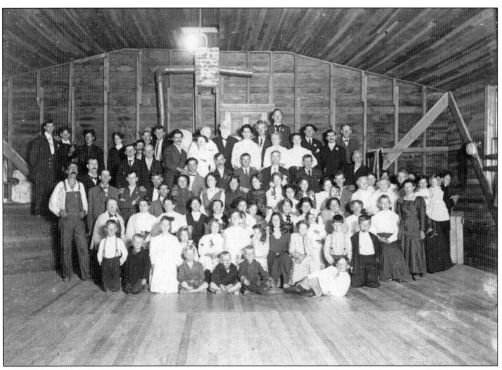

Home residents gather at Liberty Hall for an evening of entertainment; David Dadisman was 12 in 1910 when this photograph was taken. The lower level of the hall held two classrooms, a kitchen, and Jay Fox's printing office. Musical and educational programs, meetings, and dances took place upstairs. (Courtesy Chester E. Dadisman.)

Evelyn Dadisman runs across the street from her home to a masquerade party at the Home hall on the waterfront. Built on pilings, it was the fourth structure in the community to serve as a hall. Dadisman's mother made costumes for all occasions. Evelyn, her brother Chester, and playmates in Home continued the tradition of children of that community by writing, producing, and presenting plays and other entertainment. (Courtesy Evelyn Dadisman Evans.)

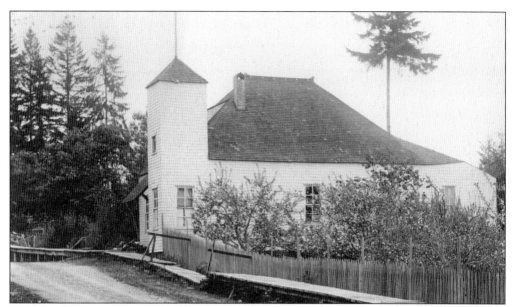

The Vaughn Library Hall started as a dance floor built by the young men for a Fourth of July celebration in 1889 on Alfred Van Slyke's land. The building was used for high school classes, church services, and as a meeting place. The boys' Sunday school classes met in the bell tower. A fourth-generation Van Slyke descendant lives there now. (Courtesy Dulcie Schillinger.)

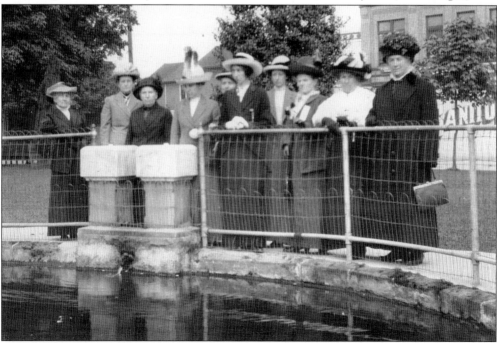

The ladies of the Vaughn Library Association traveled to the Washington State Historical Museum in Tacoma in 1906. They collected and shared books for several years before they had a permanent home in a corner room of the new Library Hall in 1891. Augusta Dodd stands at far left; Ella Davidson is third from right. Other ladies may include Amanda Wright, Mary Jeanette Van Slyke, Lucy Goodman, Hattie Irwin, and Margaret Mary Austin.

The community added a room for the library before the 40th anniversary celebration of the Vaughn Library Hall. Their collection held over 2,000 books. The library moved to the new Key Peninsula Civic Center in 1956. This room now houses the KPHS museum. Pictured in 1956 are, from left to right, Denise, Susan, and Ron Schillinger, Vaughn Library Association president Lily Visell, and Billy and Jimmie Broughton.

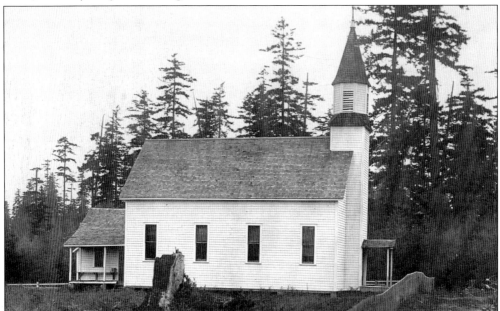

The Old German Lutheran Church, the first church built on the peninsula, provided services in German for early settlers of German and Scandinavian descent. Built in 1890, it served until the English-speaking people in Longbranch organized their church. Those Germanic peoples who preferred to be part of the American way of life left the old congregation. The building at Meridian lasted until an arson fire destroyed it.

Dr. Stephen Penrose, president of Whitman College in Walla Walla, spent summers at Penrose Point and proposed building a Longbranch Congregational church. He preached for them when on the peninsula, and the congregation named their social hall Penrose Hall. Built in 1909 and in use until the 1930s, when the hillside began to slide, it became one of the significant sights for incoming boats. Abel and Leda Rickert donated land for the second church. Charles and Ivanell Glasson bought the first church property, dismantled the building, and contributed the tinted-glass window, bell, and Bible to the new one, completed in 1948. Eloise Paul later donated a stained-glass window in honor of her late husband, Lyle, former pharmacist and Longbranch Mercantile storekeeper. The exterior window is the original; the interior is the Paul window. (Courtesy KPHS, Longbranch Community Church.)

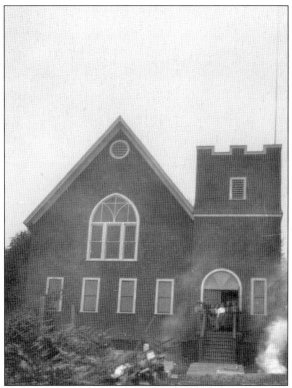

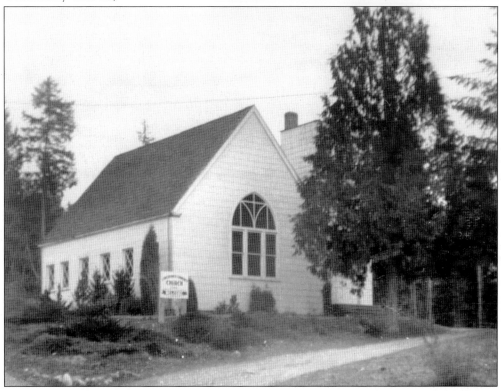

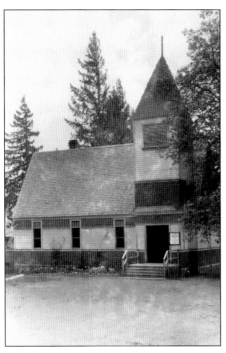

Robert Taynton designed the first church in Vaughn to resemble a Swiss chalet, and it is shown here about 1925. Community members built it with Applegate mill lumber. A Presbyterian, Congregationalist, and finally a community church, it is the oldest existing church building on the peninsula. A couple from out of the area bought it in 2007 to use as a family retreat, after fire damaged the structure in 2006. (Courtesy Dulcie Schillinger.)

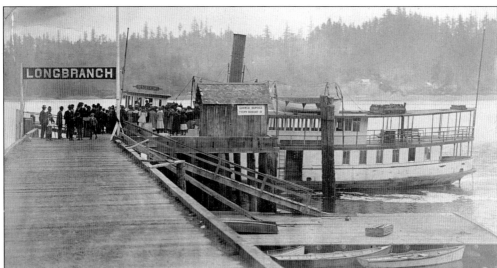

The *Tyrus* stops at the Longbranch dock to unload and pick up passengers and freight. The sign on the waiting shed notes the time of services at the Longbranch church, about half a mile up the road. Built in 1904, the *Tyrus* became the largest vessel yet added to the Case and Carr Inlet fleet. Her original engine came from the *Typhoon* and was later replaced with a triple-expansion engine fired by coal. At 98 feet with a 17-foot beam, the engine was too powerful to open the throttle to maximum revolutions. The *Tyrus*, as flagship of the harbor fleet, served as official boat for the welcome committee and band when the U.S. cruiser *Washington* came to Tacoma. Fare for the general public was 25¢ for that celebration. In 1918, the West Pass Transportation Company bought *Tyrus* and renamed her *Virginia IV*; she remained in use until 1921. At that time, her engine, boiler, and condenser were put into the newly built *Virginia V.* That engine, over 100 years old, keeps *Virginia V* running in Puget Sound as an excursion boat.

Seven

GETTING AROUND THE PENINSULA

A multitude of small boats carried freight and passengers around Puget Sound from the time of early settlements until trains, ferries, and automobiles replaced them.

The mill business run by Carl Lorenz and his sons prospered, and they headed for Seattle with lumber, rowing a specially built scow. They stopped in Tacoma after difficult progress. The problems of managing a slow-moving scow through the waters of Carr Inlet convinced them to build a steam-powered boat.

At least two stories exist of how Capt. Ed Lorenz saved the citizens of Home. Some Tacoma citizens, incited by *Tacoma Ledger* editorials, planned to charter a boat to close down the anarchist settlement of Home with their own brand of justice. Captain Lorenz, learning of their intent, feigned engine trouble until it was too late to cross to Home. He returned to the dock and gave back their ticket money.

The second story tells of a representative from Tacoma visiting Home on Captain Ed's boat, where residents treated him to a tour and grand meal. He returned to Tacoma, cornered the editor, told him what fine citizens the people of Home were, and the planned raid was called off.

James Ulsh, deckhand then mate on the *Arcadia*, hauled the mail to the post office on his way home after unloading the freight. Co-op night meant feed sacks, which took longer. His wife learned how to time dinner from the boat whistle being blown.

Ulsh was called "the seagoing cowboy" because of his unique way of coming in to land at the docks. He never tossed the rope with a loop in the end to helpers on shore. They knew better than to try to catch it. Instead, he lassoed the tall piling. A *Tacoma Times* reporter once asked what would happen if he missed. Ulsh replied, "I don't know because I never miss."

Other boats serving the peninsula included *Bessie*, "a little steamship with a big whistle"; Mississippi River style stern-wheelers *Messenger* and *Monte Cristo*; a freighter built in Allyn, *E. M. Gill*; as well as *Alice, Audrey, Blue Star, Burro, Old Bob Irwin, Susie,* and *Ronda*.

The only daughter of Carl Lorenz, Meta, whose name graced the second Lorenz boat, could handle the boats as well as her brothers could. *Meta* replaced *Sophia* on passenger, mail, and freight runs. She was sold in 1909, renamed, and lost off Coos Bay, Oregon, on her transfer to Mexico. Gilbert, son of Ed Lorenz, said no more boats would be named for family members, as it was too painful to sell or lose them. Below, Capt. Ed Lorenz, left, and Capt. Bert Bernston, right, stand on the *Arcadia* with an unidentified man in 1939. (Courtesy Ann Lorenz Craven.)

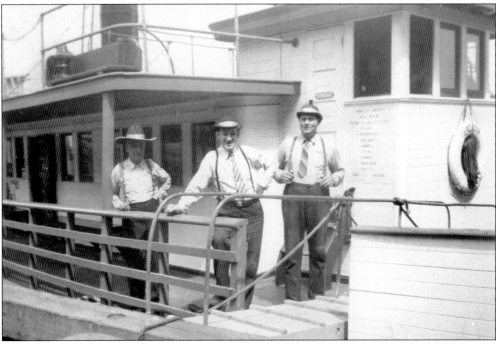

In 1918, Bert Bernston purchased the *Thurow*, built by Ed Lorenz; formed a partnership with him; and transported his family to Lakebay on this boat. Captain Bernston piloted most of the runs for Lorenz-Bernston Navigation Company, with Lorenz taking occasional turns. (Courtesy Ann Lorenz Craven.)

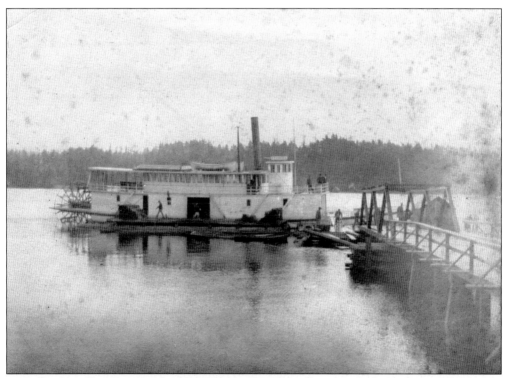

Tyconda, the only stern-wheeler of the Lorenz-Bernston fleet, was built for them in Tacoma in 1901. She did the Henderson Bay to North Bay run in Case Inlet. Sold in 1914, she burned in Alaska the following year. (Courtesy Ann Lorenz Craven.)

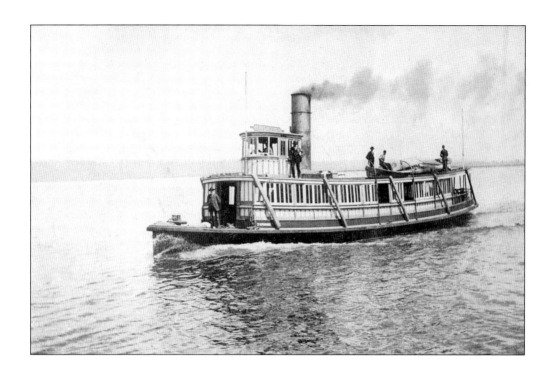

The Lorenz-Bernston steamship *Typhoon* originated as a ferry on the Willamette River in Oregon. Lorenz bought it in 1894 to run with *Meta* on the Tacoma/Upper Sound routes. She ended her days as *Dove*, a Willapa Harbor tug. *Typhoon II*, pictured below, became part of the West Pass Transportation Company fleet for the west side of Vashon Island in 1914 as *Virginia III*. Her distinctive locomotive-like whistle, called the West Pass Whistle, was moved to *Virginia IV* when she replaced *Virginia III* on that run.

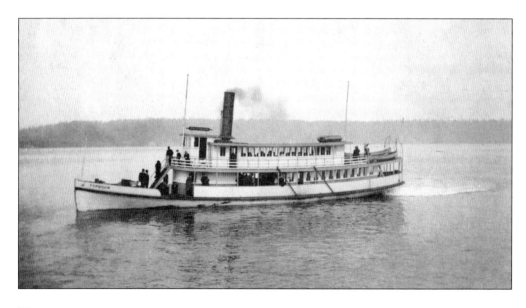

The steamship *Tyrus* was the first boat of the Lorenz-Berntson fleet flat-bottomed enough to go onto the beach. When the tide was too low for landing at the dock, *Tyrus* pulled onto the sandspit, as in this picture at Vaughn, and people rowed out to deliver or retrieve passengers and freight.

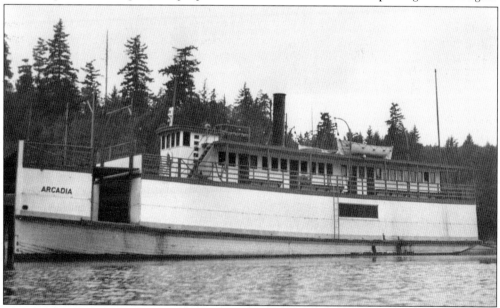

The *Arcadia* held the title of last and longest-running steamship that serviced the peninsula, which she did from 1928 to 1941. Thirteen-year-old Virginia Berntson christened her with grape juice. *Arcadia* carried a Stanley Steamer engine to power a freight elevator for more efficient loading. She became a McNeil Island ferry/supply boat named *J. E. Overlake* after Lorenz died and Bernston retired. Puget Sound Excursion Lines purchased her in 1959, renamed her *Arcadia*, and then changed the name to *Virginia VI*.

Glen Harriman's third freight/passenger boat, *Loren*, seen here in Pickering Passage, shows Harriman in the wheelhouse and his cousin Arthur Wingert next to him. Harriman captained the 54-foot *Loren*, powered first by gas, then steam, and finally diesel, until 1936. He sold it to Ray Bussard, who used the boat as a fish carrier in Alaska for several more years. (Courtesy Mary Georgene Knudson.)

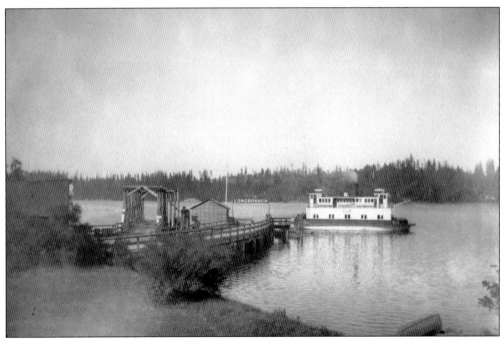

Mitchell Skansie of Gig Harbor widened out a purse seiner to make the *Elk*, the first ferry between Longbranch and Steilacoom, with stops at McNeil and Anderson Islands. In this 1922 photograph, she stops at the Longbranch dock. *City of Steilacoom* replaced her two years later and operated until 1938. (Courtesy Elvin Floberg.)

The Taylor Bay ferry carried cars and passengers between Taylor Bay and Puget City near Johnson's Point, north of Olympia, from 1937 to 1942. At age 10, Helen Stolz became sick and in the middle of the night cried, "I'm dying!" Her mother ran to get Harold Hanson, the ferry operator. They crossed to Johnson's Point and drove to Tacoma General, where Helen had an emergency appendectomy. (Courtesy Helen Stolz Fravel.)

M/V *Charlie Wells*, named for a much-loved captain, makes regular runs between Herron Island and the peninsula. Once, Capt. Steve Farris noticed a small aluminum boat with a man hanging onto the outside. He helped the man back into his boat, and the story became an island legend. The hapless fisherman had snagged a salmon and hauled it aboard, but the lawn chair he was sitting in flipped, sending him overboard. (Courtesy author's collection)

The mail boat *Eagle*, captained by Glen Elder, made its rounds carrying mail and passengers between Steilacoom, Anderson and McNeil Islands, and Longbranch in 1921. William Sipple of Longbranch built the *Eagle*, a launch that stopped for passengers or freight at docks with flags up. *Eagle II* followed, using the same route and captains.

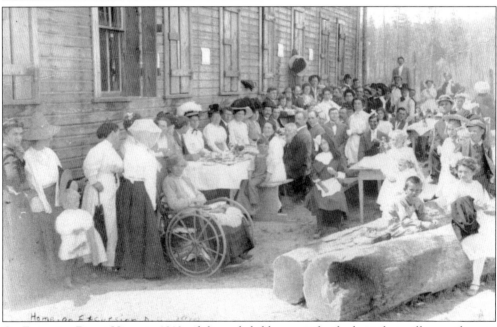

On Excursion Day at Home in 1910, adults and children wait for the boat that will carry them to a picnic or a special event. The boats operated as freight boats six days of the week. On summer Sundays in good weather, the captains offered pleasure excursions to Point Defiance, Olympia, Hartstene Island, and other destinations. Glen Harriman carried local young people to Saturday night dances at Jarrell Cove.

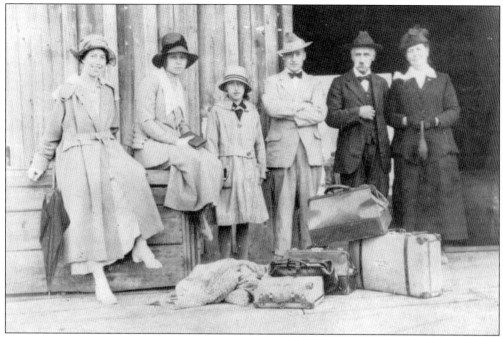

Waiting for the steamer at Glencove are, from left to right, Docia Dodd, Elsie Reid, Doris Reid, Roy Dodd, and Ernie and Lilly Reid. The Dodd siblings lived in Vaughn and were bidding their guests, the Reid family, good-bye after a visit. The date would be in the early 1900s.

Leila (Allen) Edmonds and daughter Sylvia enjoyed an outing on the Home waterfront in 1920. Sylvia, granddaughter of George and Sylvia Allen, cofounders of the Home colony, compiled a six-volume history of Home with photographs, letters, and assorted documents. (Courtesy Sylvia Retherford.)

Helen Stolz, on her way to school in 1935, stops on the Taylor Bay Bridge to have her picture taken. When the old wooden bridge needed to be replaced, the workers left two planks for Helen to cross on, as it was the only way she could get to school. (Courtesy Helen Stolz Fravel.)

The Purdy Bridge, the fourth to cross the open water between Henderson Bay and Burley Lagoon, was the first in the United States to use reinforced-concrete box girders. It boasts a central span of 190 feet. Considered an engineering landmark with a unique design for its era, it stood out in a National Park Service survey of bridges and tunnels in the state. The Purdy Bridge was placed on the National Register of Historic Places in 1982. (Courtesy author's collection.)

John G. Shindler, aboard Ed Lorenz's boat about 1889, said, "Captain, some day you will see a bridge over these Narrows." Lorenz recalled the conversation years later when the possibility of a bridge neared reality. "We all thought Shindler was crazy," he said. The Tacoma Narrows Bridge, the third longest suspension bridge in the world, dubbed "Galloping Gertie" because of its motion, lasted about four months. James Bashford's photograph shows its demise in 1940. The next morning, the state returned to service the Skansie ferries. Revenues from the first bridge exceeded expectations and proved the need for such a structure, but the advent of World War II delayed the replacement, pictured below, until 1950. A second span, parallel to the existing bridge, opens in 2007. (Courtesy Gig Harbor Peninsula Historical Society and Dulcie Schillinger.)

This Longbranch team won the Lincoln Bowl in Tacoma and became the Pierce County championship team in 1939. Marvin Rickert (far right, back row) followed two uncles to play for Tacoma teams. He played on five major league teams, including the Boston Braves. He was with the Braves in the 1948 World Series, and he hit the only home run for his team. Most of the peninsula population stayed glued to their radios to hear that game. Rickert's cousin, Dave Rickert, played with the St. Louis Browns farm team in Redding, California, soon after high school. Batboy Fred Rickert Jr., a cousin of Marvin, sits in front. Pictured from left to right are (first row) Pete Bussard, John Schultz, Paul Challender, manager Al Tillman, Louis Anderson, Stan Anderson, and Swen Anderson; (second row) Leo Geffin, Don Summerfelt, Rogner Johnson, George Heinkel, Milt Rickert, Ralph Rickert, Dr. Samuel Lawrence, Wallace Tillman, Harry Curl, and Marvin Rickert.

Eight

FUN AND GAMES ON THE KEY

Early settlers on the peninsula did not have much time to think about physical recreation, although children living on or near the water enjoyed swimming, boating, fishing, and beach play from an early age. Pioneer children spent a lot of time outdoors, whether doing farm chores or spending time with friends.

Boating began with rowboats, and every child near the water learned to swim and row at an early age. Lawrence Beck received his first rowboat at age three-and-a-half and rowed out to pick up his mother when the steamer arrived.

With more leisure time, various forms of recreation and entertainment sprang up around the peninsula.

Sunshine Beach Resort in Vaughn came about in the 1930s, when Gordon Kingsbury's chickens developed coccidiosis. Two new chicken houses furnished lumber for a store, dock, and some cabins on his low-bank waterfront property. The store sold candy, cigarettes, and like items, but the best part, according to Audrey (Whitfield) Paul, was the ice cream. She ran across fields to buy a brick to take home for a special treat.

In the late 1940s, Harry and Juanita White converted the old Lakebay community hall into a roller-skating rink. Weyerhaeuser provided 4-by-8-foot sheets of plywood the company wanted tested and returned on call to inspect and repair floor damage. Skaters used clamp-on skates, and local folks enjoyed that sport for about five years.

Baseball was king in the years before the wars. Teams from Tacoma arrived by boat, and one time, a Longbranch team was filled out with inmates from McNeil Island Penitentiary.

Sunday afternoons meant baseball games, with families arriving by horse and buggy at first and later by cars. Ball retrievers received a reward of a free ice cream cone, with great competition among the younger set. One child, bullied by bigger kids, learned how to handle that. If he found the ball first, he hid until the others gave up or chased the next ball, then ran fast to collect his treat.

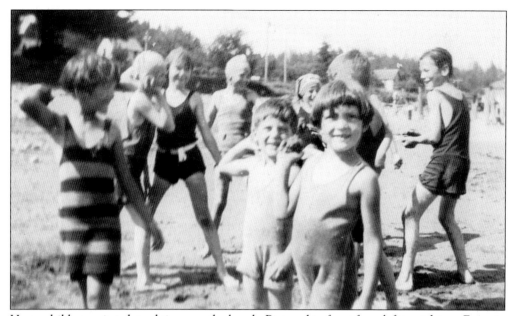

Home children enjoyed good times on the beach. Pictured in front from left to right are Eugenia Ahearn, David "Budge" Dadisman, and Virginia Ahearn, who are preparing their sand balls to throw. Others, from left to right, are two unidentified girls, Esther Movall, Evelyn Dadisman, Chester "Chet" Dadisman, and Stanley Paul. (Courtesy Evelyn Dadisman Evans.)

From left to right, Ann Lorenz; Marlene Gateley holding Moon Mullins, the Lorenzs' dog; Rosalie Gateley; and Joan Lorenz return from a swim at Lakebay in 1941. The Gateley sisters learned to operate the switchboard when their parents bought the Lakebay Telephone Company. Their switchboard closed down about 10:00 p.m. each evening. The Lorenz girls are granddaughters of Capt. Ed Lorenz. (Courtesy Ann Lorenz Craven.)

William Sipple of Longbranch takes friends for a ride on Filucy Bay in a boat he built. Sipple recorded his memory of the story of Filucy, the beautiful Native American bride of Pierre Legard, but did not share it for many years. Copies of Sipple's version of the story are in the KPHS museum and were included in Robert T. Arledge's *Early Days of the Key Peninsula*.

Bertha Gabrielson paddles her canoe in Vaughn Bay, a few years prior to her 1918 marriage to Robert Davidson. Her father, Thomas, picked up a business card dropped at his feet by the wind and moved his family to Vaughn to work at Bassett's prune dryer when Bertha was a small girl. (Courtesy Peggy Davidson Dervaes.)

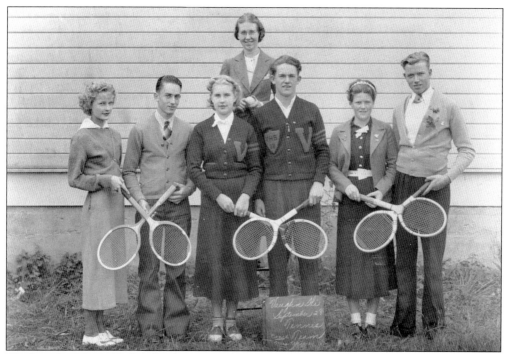

The Vaughn Union High School tennis team poses with coach Sylvia Wayne in 1938. Pictured from left to right are Edna Vitol, Wesley Davidson, Verna Vitol, Bill Ahearn, Jane Bradley, and Ralph Kingsbury. Some Vaughn folks constructed a grass tennis court on Van Slyke property near the hall before the cement one at the high school was built. (Courtesy Hazel Kingsbury.)

A game of tug-of-war pitched local teams against one another at the annual Longbranch Fourth of July celebration in 1949 at the Longbranch Improvement Club. Hank Curl's garage at the back of the picture sits on Curl homestead land. Curl's children walked across the road to go to Longbranch School No. 328.

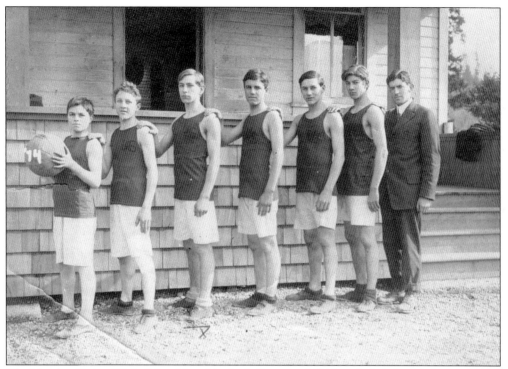

The Vaughn Union High School boys' basketball team of 1912 included, from left to right, Ed Marshall, Cliff Sharpe, Elmer Olson, Myron Kinkaid, Don Hodge, and Dewey Rodman, shown here with teacher and coach, Prof. Sidney Whitworth.

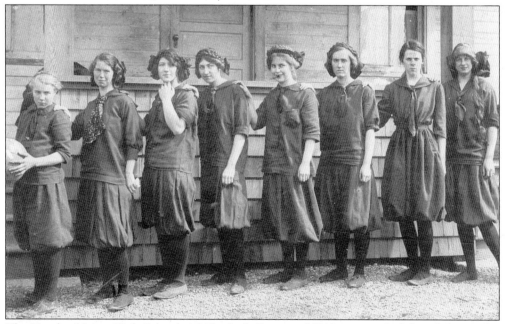

The Vaughn Union High School girls' basketball team of 1912 consisted of, from left to right, Freda Lackey, Mattie Sampson, Fairy Howell, Genevieve Moffatt, Edith Olson, Bertha Gabrielson, Helen Rodman, and Mildred Condon.

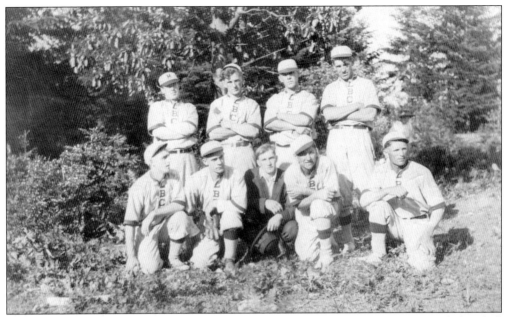

The Rickert brothers, strong young men with energy left after chores were done, brought baseball to Longbranch in the early 1900s. This early Longbranch baseball team consisted of mostly Rickerts. From left to right are (first row) unidentified, Heine Rickert, unidentified, Julius Rickert, and Joe Rickert; (second row) unidentified, George Rickert, Al "Windy" Rickert, and Al "Slick" Rickert.

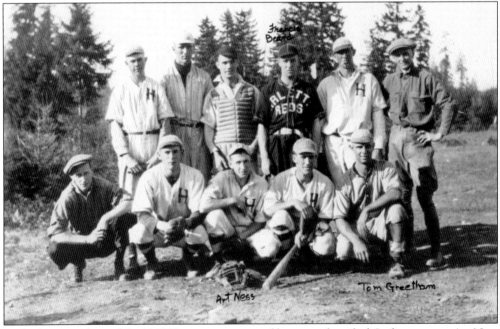

Only three members of the 1915 Home team pictured here are identified. In first row are Art Ness (third from left) and Tom Greetham (far right). In the second row is Francis Beard (third from right). The Home ballpark, on Seventh Avenue between C and D Streets, held a grandstand with concessions below. The Longbranch ball club built a grandstand for their ball field, too.

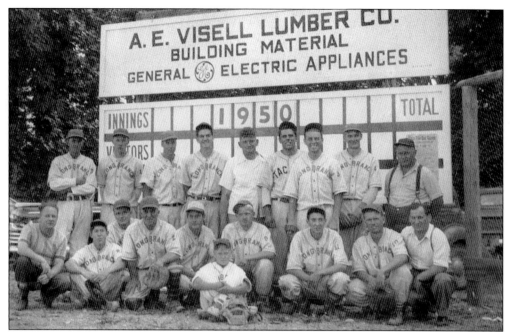

The Longbranch baseball team of 1950 stands in front of the A. E. Visell–donated scoreboard, with batboy Fred Boquist in front. From left to right are (first row) Roy Armour, Eugene Strope, Dick Radonich, Shorty McVicker, John McCoy, Loren Hyde, Clarence Langerud, Vernal Hyde, and Al Dorfner; (second row) Lawrence "Bud" Curl, Lawrence Jopp, Eric Movall, Tom Orser, Milton Rickert, Fred Rickert, Don Lind, Dave Rickert, and John Schultz Sr.

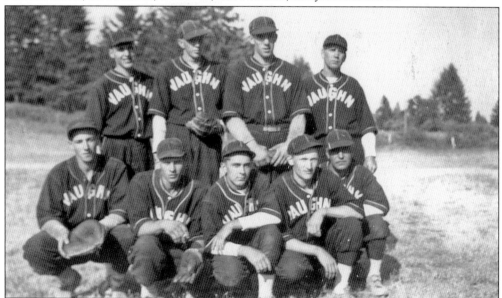

The Vaughn town team of 1934 poses for its picture. From left to right are (first row) Glen Whitfield, Mathis Van Lannen, unidentified, Bob Hetu, and unidentified; (second row) Emmett Johnson, Axel Niemann, Henry Niemann, and unidentified. The first organized team in Vaughn included six Niemanns from two families. Caroline Niemann, mother of three of them, encouraged them all—and rooted loudly at their games.

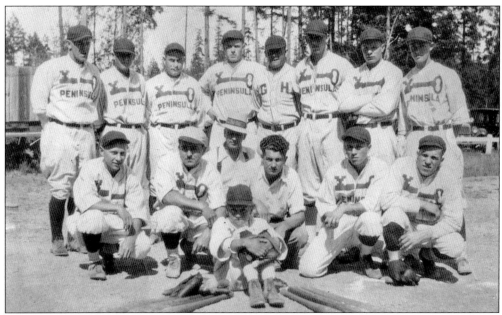

This Key Peninsula team won the Pierce County championship in 1932. From left to right are (first row) batboy Marvin Rickert; (second row) Pete Berge, Ed Goldman, manager Jess Porter, Bonny Winters, Herman Chesser, and Bunny Mortz; (third row) Jack Rickert, Bob Chesser, John Schultz, unidentified, Ralph Rickert, Kully Movall, Ed Nordquist, and Stan Anderson.

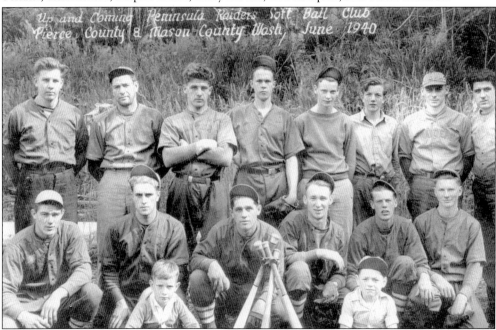

The Peninsula Raiders Soft Ball Club mainly came from Vaughn and Victor. They are, from left to right, (first row) Emmett Johnson, Dick Sisson, Julius Stock, Bob Hahn, Harry Niemann, and Bob Schillinger; (second row) Chuck Niemann, John Reed, Russ Stock, Russ Dahl, Roy Niemann, Jack Niemann, Ed Okonek, and Hank Stock. The batboy on the right in front is John Reed's nephew Gene Blair, and the other is unidentified. (Courtesy Russ Dahl.)

D'Arcy Buckell visited Washington on his honeymoon from Alberta, Canada, and then returned to Tacoma to work. He helped at Camp Seymour in Glencove, saw Vaughn, and encouraged his parents to move down in 1907. Buckell later moved his own family from Tacoma, organized and led the First Christian Church in Vaughn, and became active in local baseball. The sign below, at Volunteer Park, just south of Key Center, commemorates the commitment of Buckell to the sport of baseball. Called out of the stands at times to umpire a game, he often did the job dressed in overalls, without the benefit of protective padding. (Courtesy author's collection.)

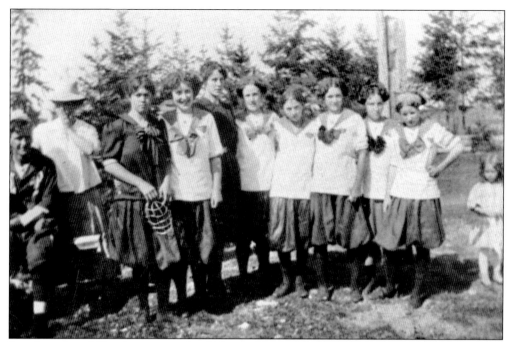

Longbranch and Vaughn organized girls' baseball teams, but they never achieved the popularity of the male-dominated sport. Men and boys heckled them, and some women thought their attire too daring. This picture shows the Longbranch girls' team of 1916.

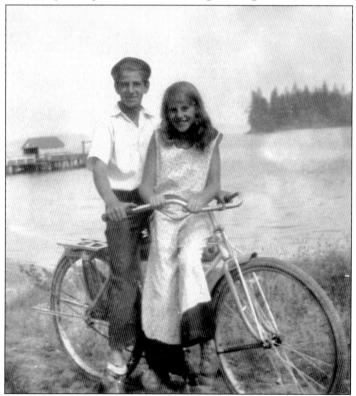

Chester Dadisman gives his sister Evelyn a ride on his bicycle in Home. Evelyn was especially proud of her "pajama outfit" with wide pant legs, all the rage in the early 1930s. Chester published a memoir of his life, and Evelyn continues to work on hers. She will tell some of the same stories from a different point of view, she says. (Courtesy Evelyn Dadisman Evans.)

Gordon Kingsbury's Sunshine Beach Resort included playground equipment for the younger crowd and a Ferris wheel with four seats. Changing houses went up, and it became the most popular place around during good summer weather. Kingsbury added a dance hall, which could be rented out for high school parties or group meetings. A nickelodeon provided music until he realized the young men figured out a way to not pay. (Courtesy Hazel Kingsbury.)

Pictured here from left to right, William Dunkelberger and Sherman Davidson of Vaughn and George Prater of Rocky Bay check out the bear one of the men just killed, about 1903. Hunting game, a necessity in the early days, became a sport but is not allowed on the peninsula at this time. (Courtesy Peggy Davidson Dervaes.)

Ron Schillinger displays a freshly dug geoduck, pronounced "gooeyduck," at Vaughn Bay. The largest member of the clam family, the geoduck lives about 18 inches below the surface. When the tide goes out, it sticks its neck about an inch above the mud. Early diggers made tubes of stovepipe or other metal, outlawed by the 1950s. A special shovel called a clam gun helps pry the giant clam from its bed. (Courtesy Dulcie Schillinger.)

Sam and Marlene Granberg purchased land to be used as a camp for the spiritual growth and pleasure of Christians in the South Puget Sound area. They donated the property to the South Puget Sound Churches of Christ in 1978. Church volunteers cleared and helped construct buildings for Delano Bay Christian Camp. Hundreds of children, first grade through high school, enjoy the weekly summer camp sessions. (Courtesy South Puget Sound Churches of Christ.)

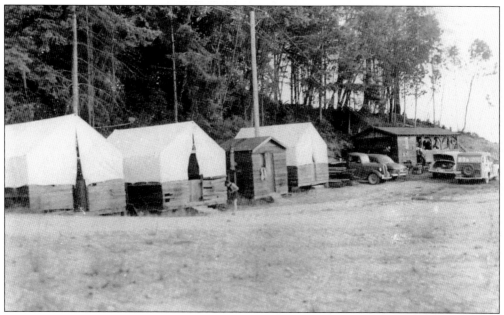

Harold Woodworth donated 10 acres with 440 feet of waterfront for a Northwest Bible ministries camp in 1945. Early campers used these tents, but today's facility at Camp Woodworth provides cabins near a large grassy area. Separate camps for boys and girls include sailing, kayaking, canoeing, rowing, swimming, field sports, archery, group games, arts and crafts, music, and survival skills The focus is character building and Christian relationships. Other camps in the area include the Olympia Presbytery Camp Soundview; Miracle Ranch, a Cispus facility; and Camp Coleman, a Seattle YMCA camp on the western side of the peninsula. Camp Stand by Me, an Easter Seal facility to serve children and adults with disabilities, occupies a site on Vaughn Bay. (Courtesy Stuart Curry, Camp Woodworth.)

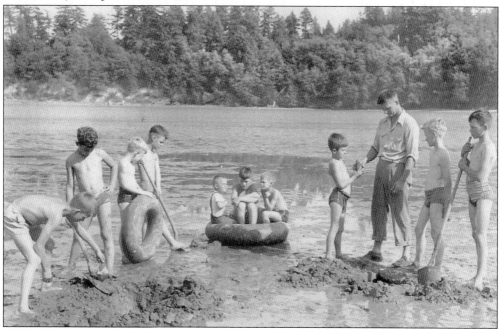

John Jewell poses with his "Balancing the Books" sculptures at the dedication at the Key Center Library in June 2002. The ceremony celebrated the library's 20th anniversary. Jewell, whose works are well-known at various Northwest locations, created life-size sculptures of Meriwether Lewis, his dog Seaman, and Sgt. John Ordway, which stand at the entrance to Fort Lewis, the U.S. Army base near Tacoma that began as Camp Lewis in 1917.

Nine

THE KEY PENINSULA COMMUNITY

The advent of good roads and automobiles encouraged people's awareness of other communities.

Consolidation of schools and a high school meant new friends.

Upper Sound Grange gathered members from across the peninsula. Firemen formed a Key Peninsula Fire District. Veterans of Foreign Wars and Lions Club organized local branches. Citizens Against Crime patrol the area and work with the Pierce County Sheriff's Department.

Communities created their own events but did not shut out those from neighboring places who wished to join. The Key Peninsula Fair replaced some events, such as Vaughn's Pioneer Day, but the Old Timers' Day in Longbranch, with live logging demonstrations, still holds its own. Sponsored in part by Key Peninsula Community House, the event's proceeds aid the local food bank and low-cost meals for seniors.

Civic-minded people worked toward common goals. The Key Peninsula Civic Center evolved as a gathering place for the larger community. History-minded people collected information and artifacts, became the Key Peninsula Historical Society, and set up a museum at the civic center.

A Key Peninsula Community Council, with representatives from each area, works toward improvement of the larger community. The Key Peninsula Metropolitan Park District oversees several parks.

Two Waters Arts Association, Dr. Penrose Orthopedic Guild, garden clubs, and other organizations do not require a specific community address for membership.

Each community still holds its own name and place, but most citizens have a sense of connection within the larger community. The peninsula has changed from a mostly agricultural/logging area to a varied group of citizens linked together through businesses, organizations, and friendships that extend beyond individual community lines.

The Key Peninsula may be a place name on the map, but it is also an attitude of people who work and play together and who share frustrations and celebrations without a concern of what area of the greater peninsula one lives in. Together, they are the Key Peninsula.

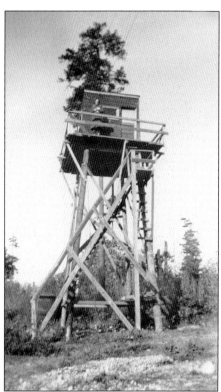

Bertha Davidson, on duty at the World War II watchtower near Lackey Road in Vaughn, surveys the skies for aircraft. Local residents manned three watchtowers on the Key Peninsula: at Vaughn, the Home ball field, and near the Longbranch Improvement Club. Searchlights lit up the night sky. Women and older girls worked daytime shifts; men and older boys took turns at night. (Courtesy Peggy Davidson Dervaes.)

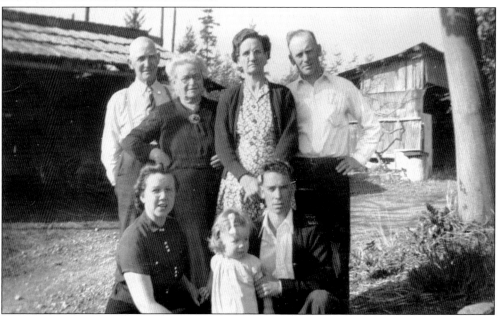

Edward Stone, a violin maker, was a relative newcomer to the area when he won $25 in a contest to name the peninsula. The map shape reminded him of an old-fashioned key. Alden Visell then called the local business area Key Center. Four generations of the Stone family are shown in 1940. From left to right are (first row) Ada, Marilyn, and Gene; (second row) Edward, Esther, Harriet, and Ernest. (Courtesy Gene Stone.)

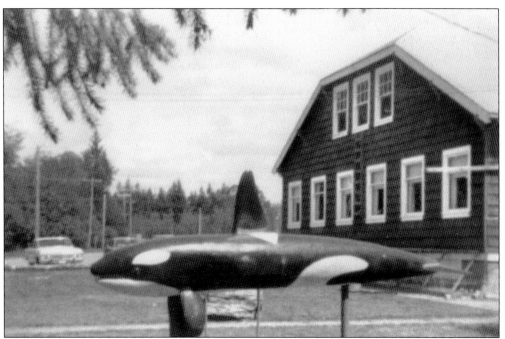

This orca at the Key Peninsula Civic Center, carved by Ned Richards in 1976, helped commemorate the country's bicentennial. Richards said he chose the orca because he has a feeling of respect and awe for these animals. Orcas have been infrequent visitors to Vaughn Bay but are seen often in Case and Carr Inlets. Schoolchildren took a field trip to see the orcas in Vaughn Bay in 1968. Two of about a dozen were captured and transported: Luna to New York City and Hugo to Miami. Called killer whales, they are nonaggressive members of the dolphin family. Their unique coloring makes them easy to identify.

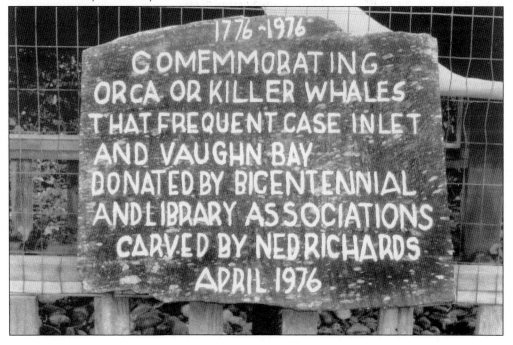

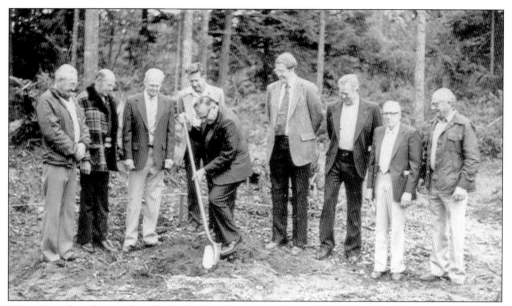

Many nonchurch members helped clear the grounds and build the Key Peninsula Lutheran Church in 1982. Pictured from left to right are Al Jacobs, Ross Bischoff, Kirk Torgerson, Ernie Jorgensen, Pastor Richard Wagner (with shovel), Tor Johannessen, Del Leaf, Carmi Swanson, and Len Cedar. In 2006, McColley Hall, the church's fellowship center, received approval as a Red Cross emergency shelter and put local talent to work for those in need after storm damage in November of that year. (Courtesy Nona Jorgensen.)

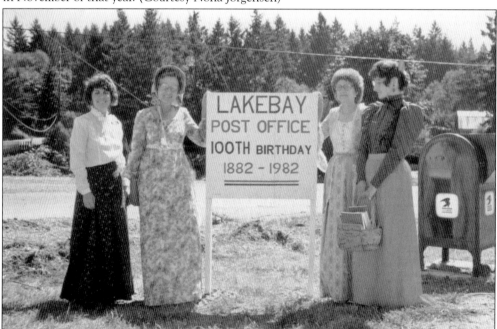

Pictured from left to right, postmaster Dottie Pierce stands with Virginia Seavy, Marguerite Bussard, and Beth Dowsley at the Lakebay Post Office centennial celebration. The post office moved locations with each postmaster until a permanent building was constructed. The Lakebay Post Office also serves Home, where it is located; Herron; and Longbranch.

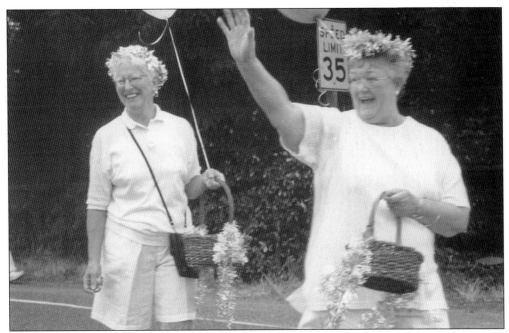

Angel Guild, an outgrowth of efforts to set up a medical clinic, has "angels" from most local communities. Profits from their thrift shop benefit peninsula groups, such as schools, the fire department, and other organizations. Angels Molly Holmes and Frankie Johnson, wearing their traditional white, march in the 2001 Pioneer Day parade from Key Center to the Key Peninsula Civic Center in Vaughn.

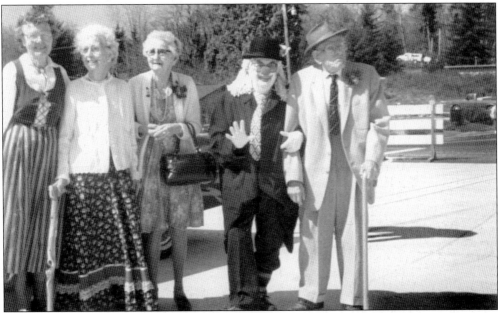

The new Home Bridge was dedicated in August 1995, with much pomp and celebration. From left to right old-timers from pioneer families are Virginia Seavy, Pearl Johnson, Ida Curl, a "friend," and Bill Otto. Such events, like the Key Peninsula Civic Center's 50th anniversary, bring people together from across the peninsula.

Barbara Bence stands at the Key Singers' table at the 2006 Livable Community Fair at the Key Peninsula Civic Center. The Singers organized in 1998 when someone remarked, "We don't have any musical talent out here." Jo Sturm proved him wrong. The group volunteers performances on the peninsula and beyond throughout the year. The annual fair, started in 2001, promotes nonprofit organizations on the peninsula. (Courtesy author's collection.)

The Home town band, organized in 1990 to get some young people involved in the Pioneer Day parade playing kazoos, graduated to a group of assorted ages. Directed by Dr. William Roes, the group became a fixture in Pioneer Day parades, at Old Timers' Day, and to prepare for Santa's appearance at the Key Corral Christmas tree lighting. Roes stands to the right of the sign. (Courtesy William F. Roes.)

Mairin Harry of Fox Island rides a Pony Man steed led by Roy Westeen of Port Orchard at the 2006 Key Peninsula Fair. Held at Volunteer Park, south of Key Center, the fair includes a carnival, petting zoo, beer garden, food court, contests, music and entertainment, and a large assortment of exhibits and vendor booths. (Courtesy Mindi LaRose.)

Lulu's Homeport Restaurant sponsored an old-fashioned hoedown in August 2006 that may become an annual peninsula event. Shown here, Madison LaRose, center, participates in a potato sack race. Other activities included candy in a haystack, face painting, best-dressed hoe contest, music, and free food. (Courtesy Mindi LaRose.)

Dorothy Wilhelm, host of Comcast television's *My Home Town*, gives instructions to local residents representing the various peninsula communities. The film covered the diversity of both historic and present-day Key Peninsula, with a tour of historic places and interviews with old-timers. Joyce Niemann and relatives prepared a live demonstration of huckleberry production, from fresh-picked berries to pie. (Courtesy Rodika Tollefson.)

The Olympia Highlanders bagpipe band, directed by Scott Lumsden (wearing sunglasses), leads Key Peninsula Veterans Institute members, who will conduct the program for the Memorial Day service at Vaughn Bay Cemetery. The Aisle of Honor, started by the Veterans of Foreign Wars Post No. 4990 in 1994, takes place each Sunday of Memorial Day weekend. Over 230 flags flew in 2006. (Courtesy Hugh McMillan.)

The Key Peninsula Veterans Institute continues this tradition with a memorial program with names of all flag owners read. Flags represent service men and women from the peninsula and others whose families have asked that their flag be added to the display. The flags go up again on Veteran's Day, weather permitting. Boy Scouts help set up and take them down at day's end. (Courtesy Hugh McMillan.)

In 2006, the Key Peninsula Veterans Institute dedicated a memorial monument at the Vaughn Bay Cemetery to honor veterans of World War II. The words on the monument read, "All gave some. Some gave all. Thank you." (Courtesy author's collection.)

ACROSS AMERICA, PEOPLE ARE DISCOVERING SOMETHING WONDERFUL. *THEIR HERITAGE.*

Arcadia Publishing is the leading local history publisher in the United States. With more than 3,000 titles in print and hundreds of new titles released every year, Arcadia has extensive specialized experience chronicling the history of communities and celebrating America's hidden stories, bringing to life the people, places, and events from the past. To discover the history of other communities across the nation, please visit:

www.arcadiapublishing.com

Customized search tools allow you to find regional history books about the town where you grew up, the cities where your friends and family live, the town where your parents met, or even that retirement spot you've been dreaming about.